BERLIN NIGHTS

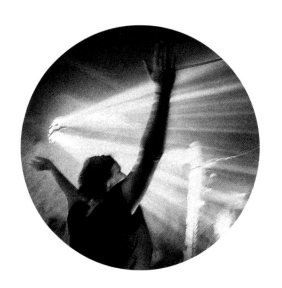

BERLIN NIGHTS

CHRISTIAN REISTER

HOXTON MINI PRESS

This book is available as a collector's edition

www.hoxtonminipress.com

From the series

TALES FROM THE CITY

Book Seven

INTRODUCTION

by Tom Seymour

Berlin is in no way beautiful. There is no Pantheon or Eiffel Tower or Casa Batlló here, no Burj Khalifa or One World Trade Center. There are no hanging gardens or ornate fountains, no Gothic domes or classical facades, no 100-storey-tall glass structures topped with swimming pools or sky bars.

Even within Germany, Berlin lacks for distinguishing features. If you want centuries-old cathedrals, go to Cologne. If you're looking for a German Square Mile, head to Frankfurt. For fashion, you might be better served in Düsseldorf. For regal canals and state-of-the-art architecture, it's Hamburg. For football and beer, Munich.

Berlin, in comparison, is brutalist and bleak. Its offices resemble egg boxes, its residential blocks are humble and squat, its weather often grey and foreboding. Look closely, and the bullet holes remain.

'Berlin,' the photographer Christian Reister says, 'is a 35mm city.' With his monochrome grain and compact cameras, Reister has spent the last 10 years navigating the city at night – in warehouse clubs and hidden bars and on long and lonely walks alone, as his young family sleep at home.

There's something haunting in his pictures, for few cities have as many ghosts. Some of Berlin's most popular monuments remind us of Germany's darkest moments – the Holocaust Memorial, the Parliament of Trees, the small plaque in a brutalist car park that recognises its former iteration as the site of the Führerbunker. Then there's the Berlin-Hohenschönhausen Memorial, built on the former prison complex of the Stasi, and the Topography of Terror,

a history museum built on the former headquarters of the Gestapo.

The experience of overarching power remains fresh in the memory of many Berliners. The Berlin Wall is now scattered, crumbling, and covered in art. But, for 28 years, Berlin was the literal dividing line between two competing ideologies. East German officials claimed the wall was built to protect good communists from the pernicious influences of Western culture, erecting watchtowers and barbed wire, employing armed officials to train spotlights on the death strip, all to safeguard its citizens from the evils of democracy.

Few cities in history have risen and fallen like Berlin. No comparable city has, in the space of a century, survived two world wars and two dictatorships. Yet, in the space of a generation, it has grown to become one of the most tolerant, progressive and outward-facing places on earth.

Reister's photographs attest to how Berlin fused itself together again, an incomplete and often anarchic process of renewal. He captures a concrete jungle thrown together at speed and without a tremendous amount of concern for the vaunted ideals of design, but one born of a rough-hewn experimentalism and a desire to invite the world in.

'I grew up in South Germany, where everything is very settled, very proper,' Reister says. 'Berlin, in comparison, was a big playground.'

Reister, who is now 46, moved into a rundown flat in Mitte as a 25-year-old bass guitarist with an obsession for indie music. 'I had a daytime job in an office. I worked one or two days a week, and it paid me enough to pay the rent, eat a doner kebab and play a lot of music,' he says.

As he became familiar with the city, so he started to photograph it. He used his camera to capture the moments Berlin's built environment, or

the character of its people, seemed capable of expressing the city's uniquely dynamic timbre.

In its freer times, Berlin has always been a remarkably creative city. And, as the remains of the wall attest, creativity has played a defining role in this new Berlin. If this was once the city of Kaisers, absolutists and ideologues, Berlin is now the city of David Bowie and Peaches, Ai Weiwei and Olafur Eliasson, Wolfgang Tillmans and Wim Wenders. 'All kinds of artists have come here to live and work right in the central districts of the city. Some big names, but more important, the many unknown creative people,' Reister says. 'There's a community of people doing their thing and we all inspire each other.'

Reister's imagery reflects the complex dualities of Berlin. Seen together, they act as something of a fragmentary history, an incomplete mosaic of a city destined to remain in flux. 'I photograph chance moments and random encounters, portraits of strangers and friends, weather and animals, buildings and streets, concrete and lights,' Reister says. 'They all add up to the Berlin I know.' These are multivalent images, both architectural and abstract, at once dark and light, simultaneously melancholic and celebratory. They're photographs of a city full of tragedy, but resplendent in its spontaneity; a place fashioned from the fantasies of Albert Speer and Kremlin bureaucrats and filled with crazies and outliers, party animals, hippies and creatives. Berlin, in its own way, is changing with the times again – the rents are increasing, the luxury brands are moving in, the artists are moving out, the city-centre clubs are closing down. Many of the places Reister photographed have already disappeared. A new generation is emerging, one whom never knew the wall and has always known the web. And so the party continues, and long may it last.

PHOTOGRAPHER'S NOTE

I would like to dedicate this book to all Berlin night owls, in particular to those who appear in this book or have been faithful companions on late-night rambles over many years: Anna, Cecilia, Frank, Sven, Andreas, Jens, Thomas, Carmen, Holger, Helen, Michele, Gianni, Eirikur. And all those whose names I have forgotten or have never known. You are this city. I thank you all.

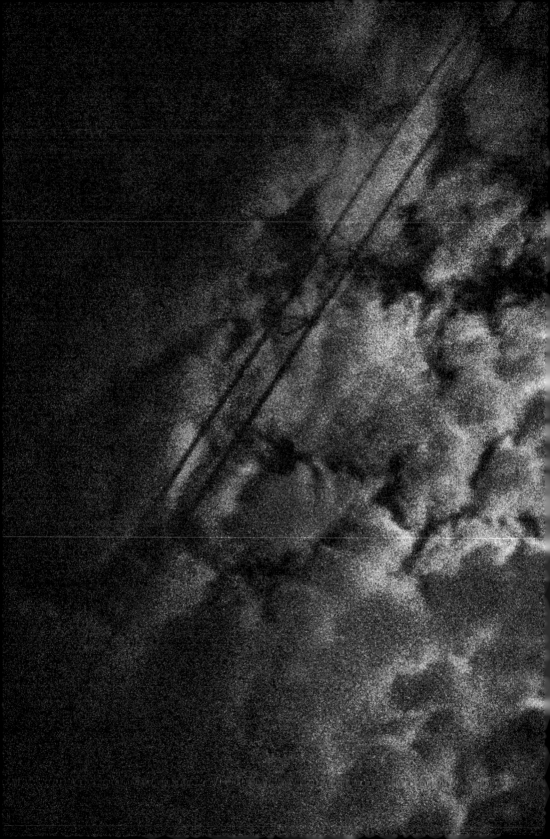

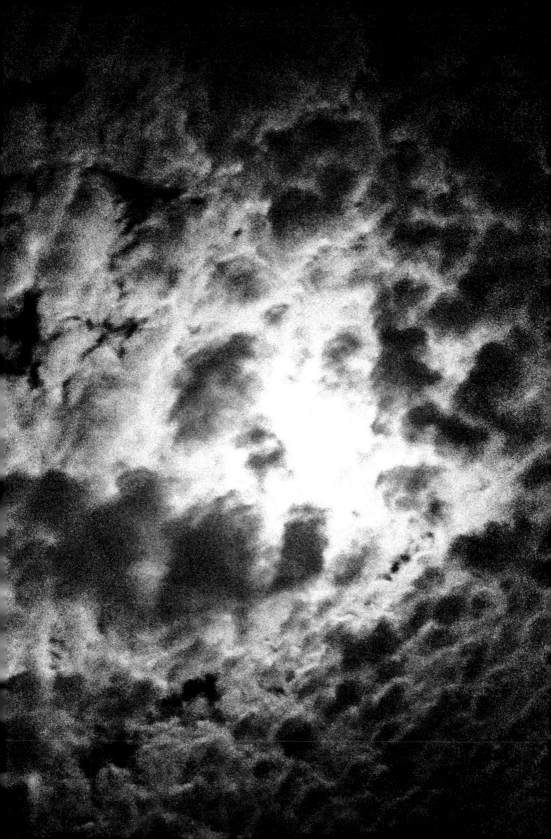

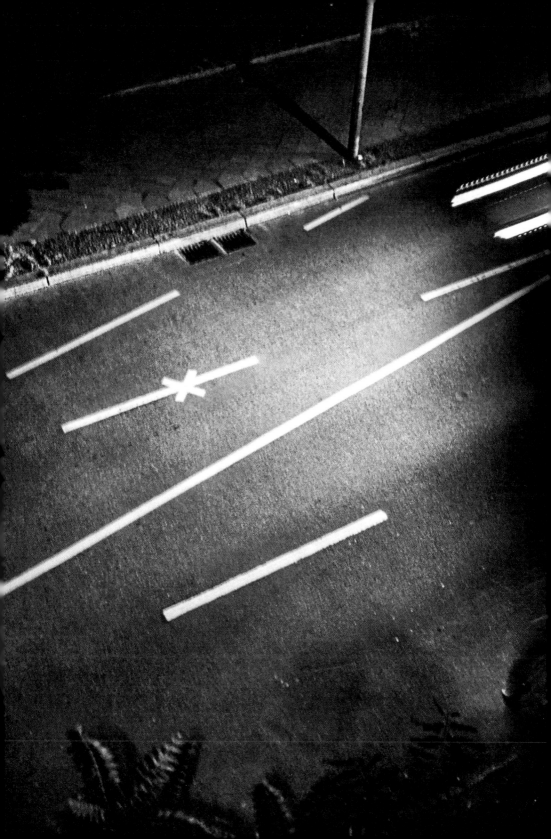

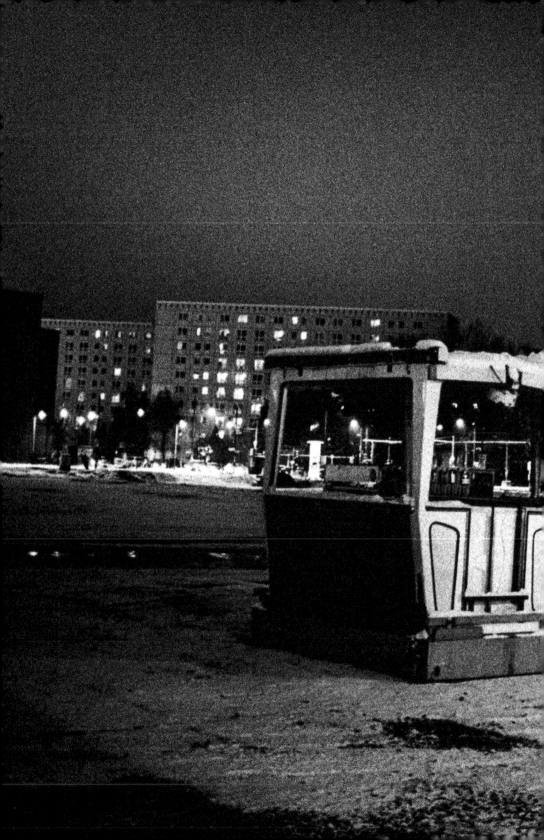

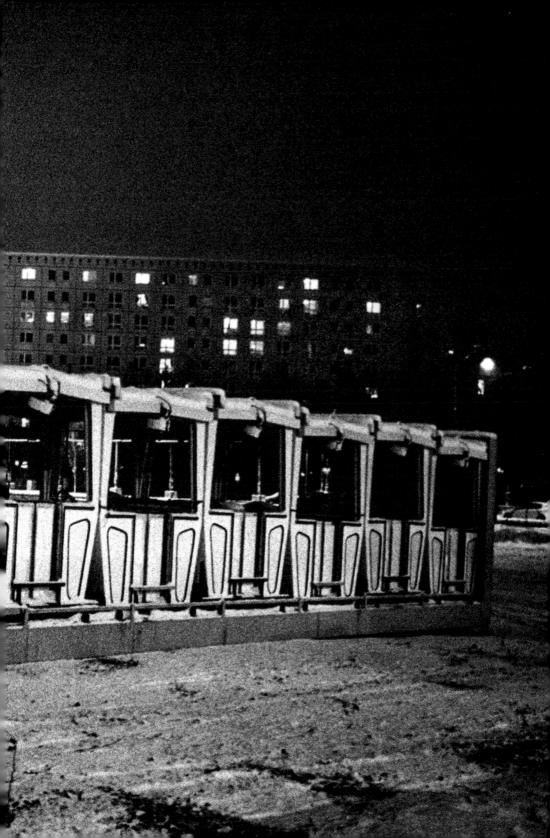

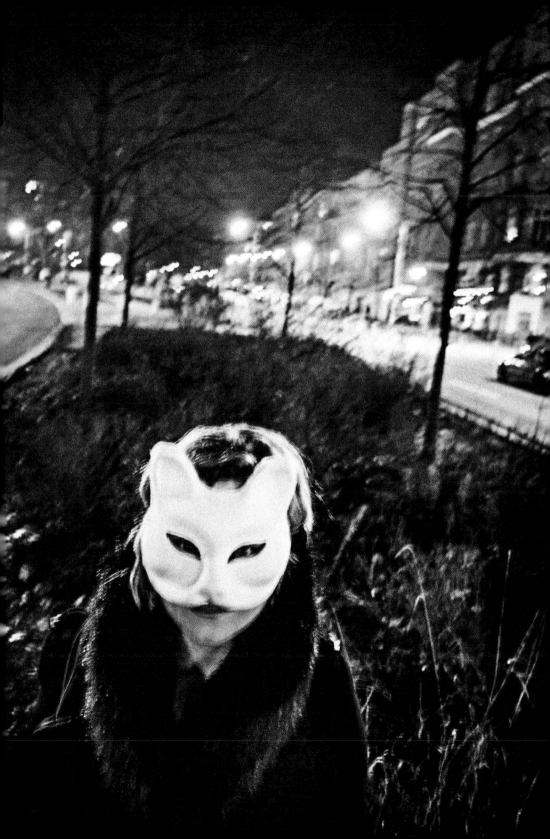

GRUNDIG

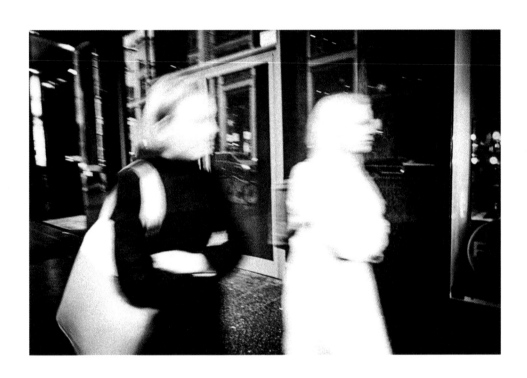

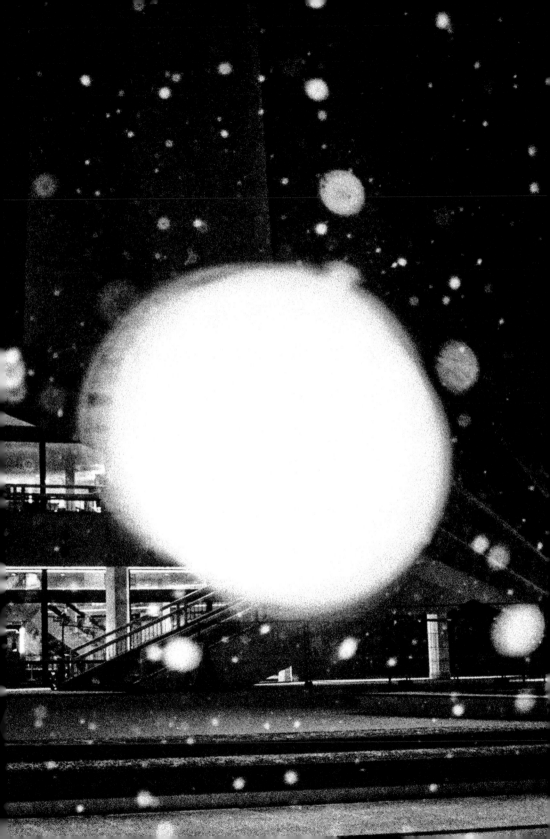

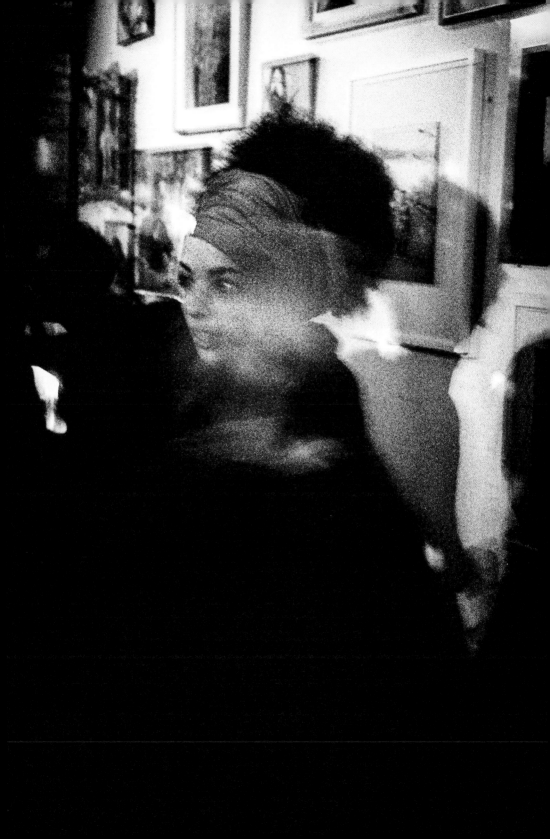

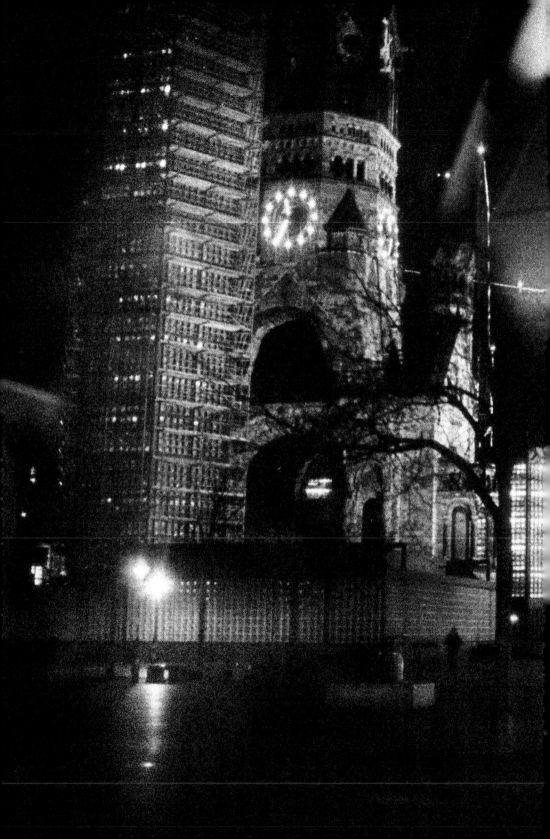

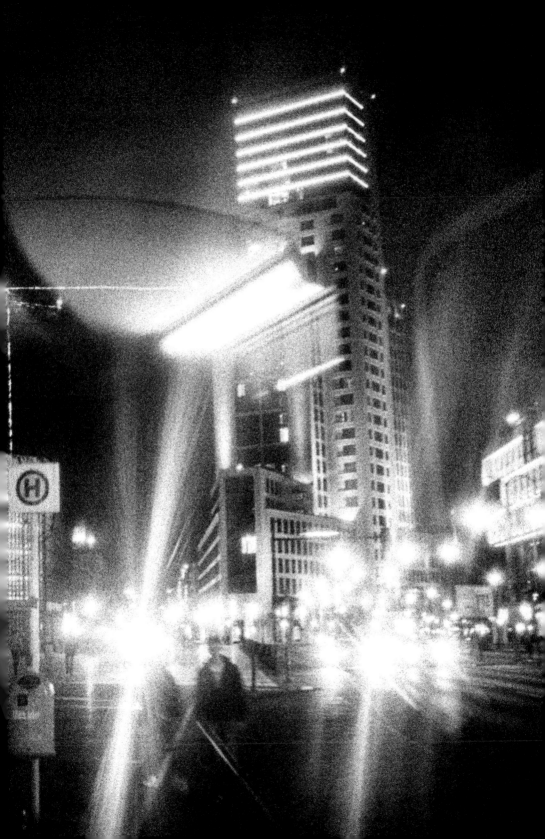

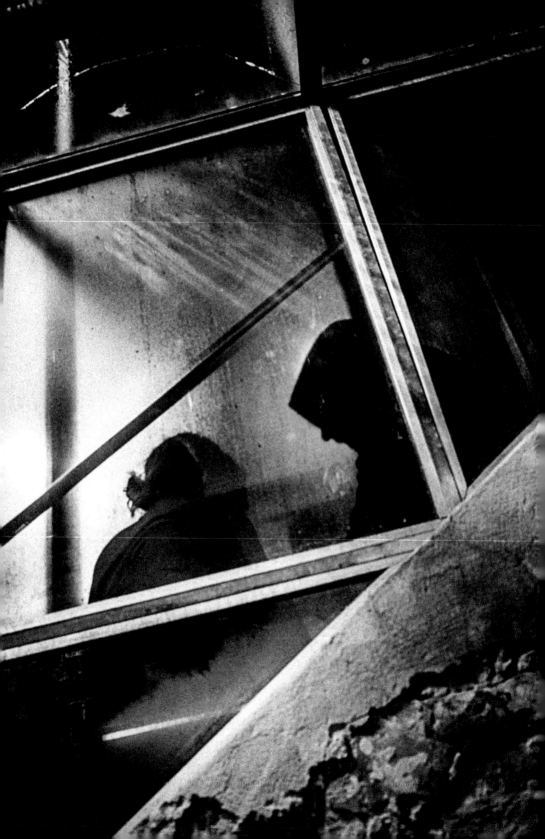

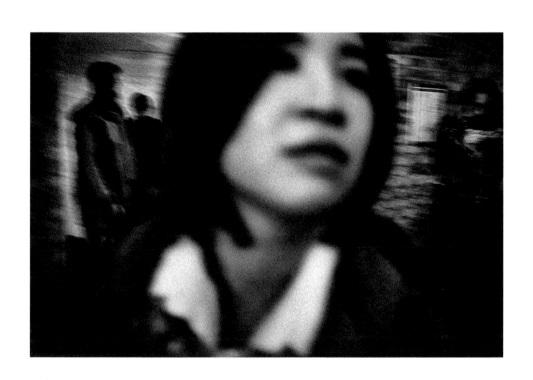

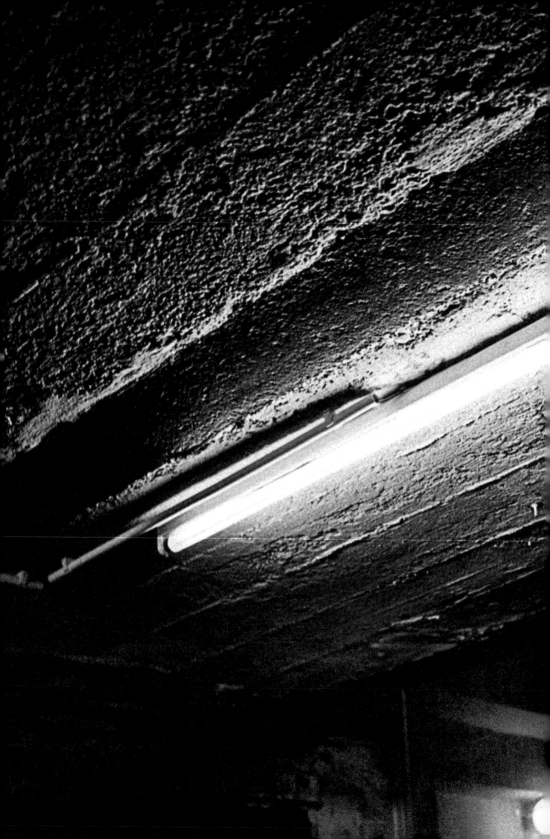

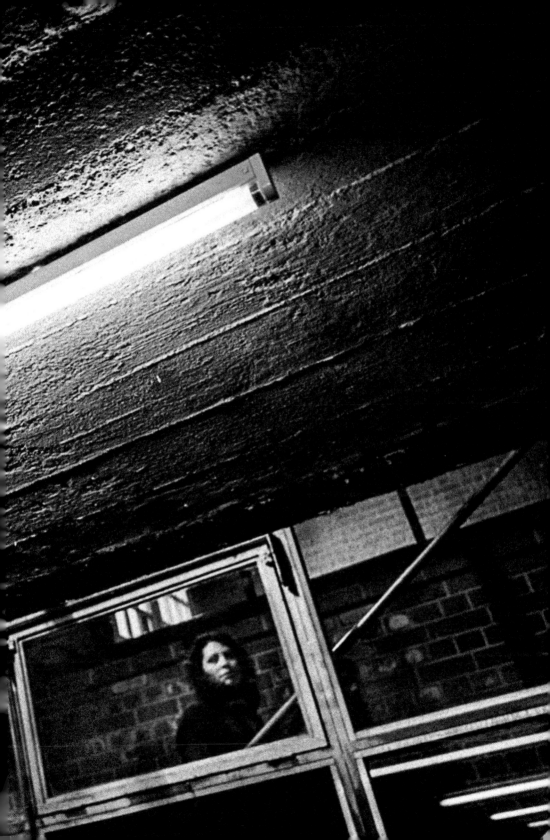

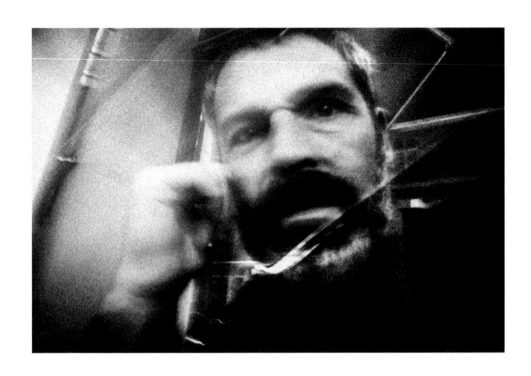

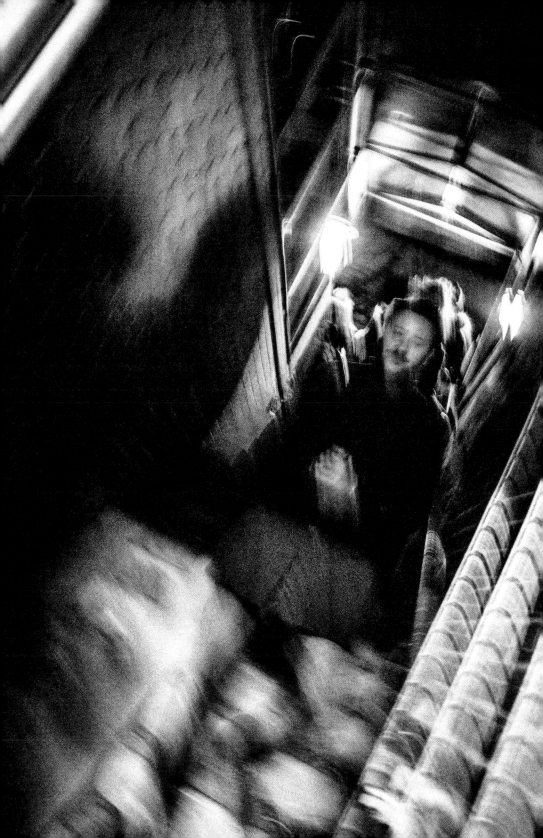

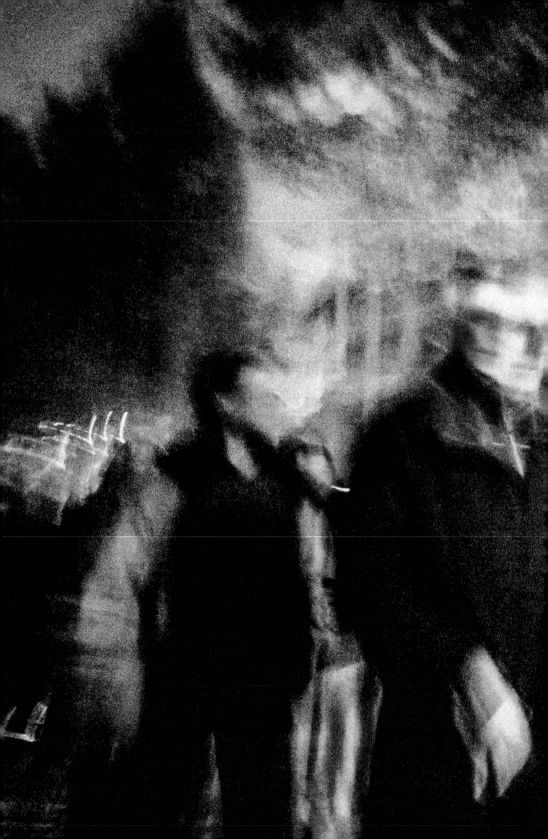

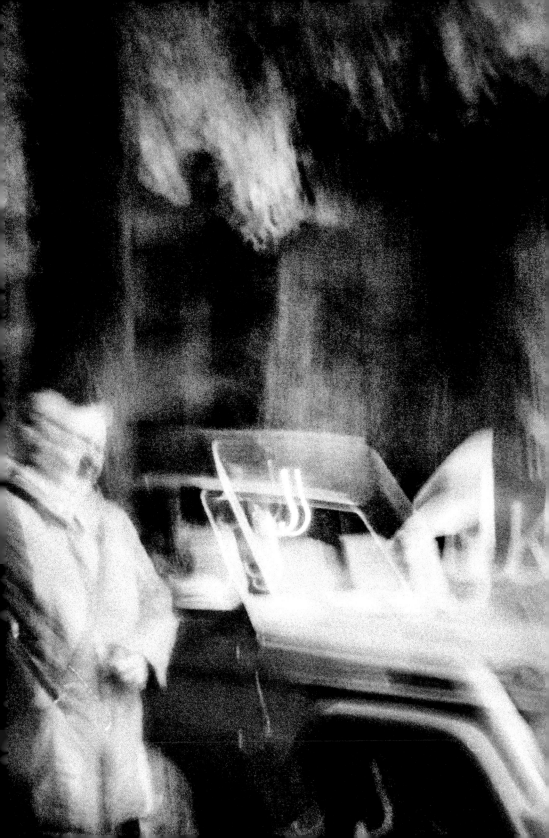

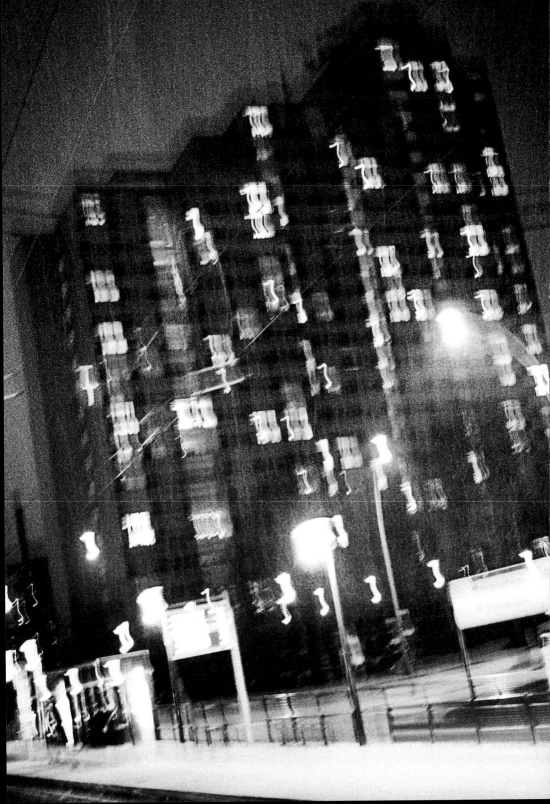

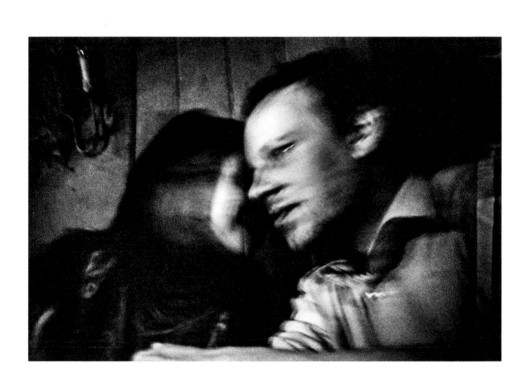

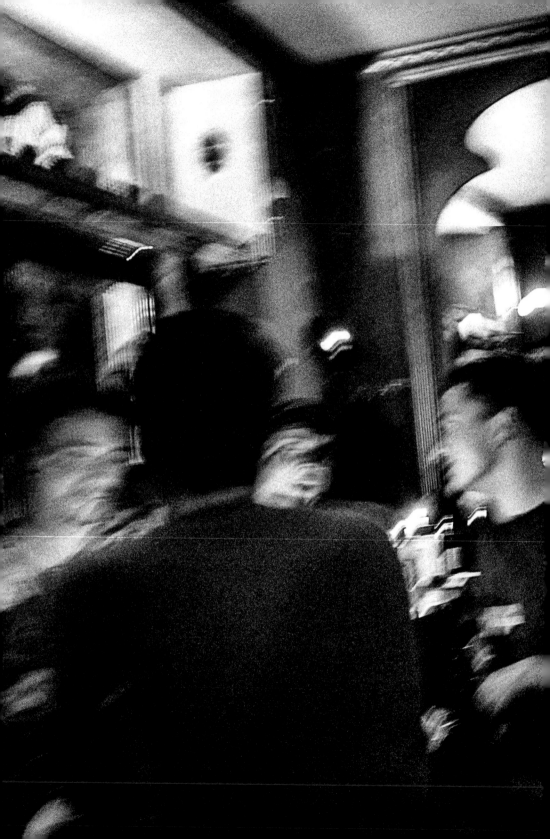

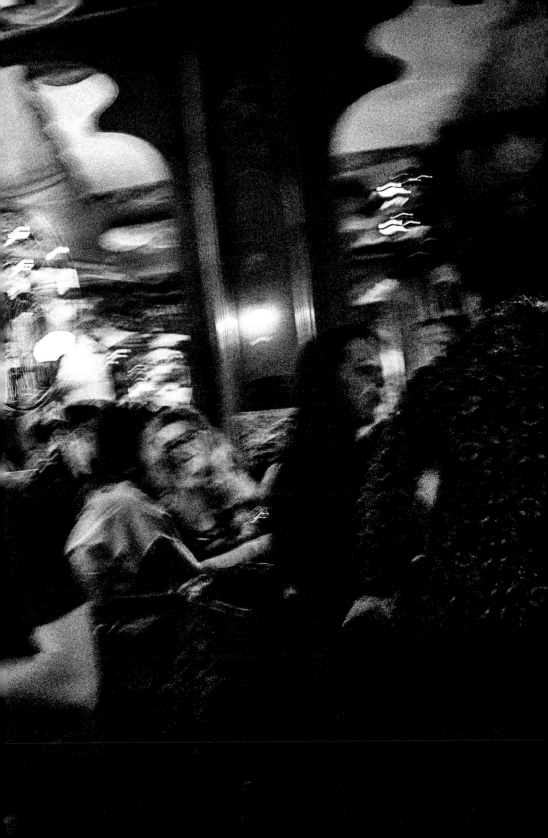

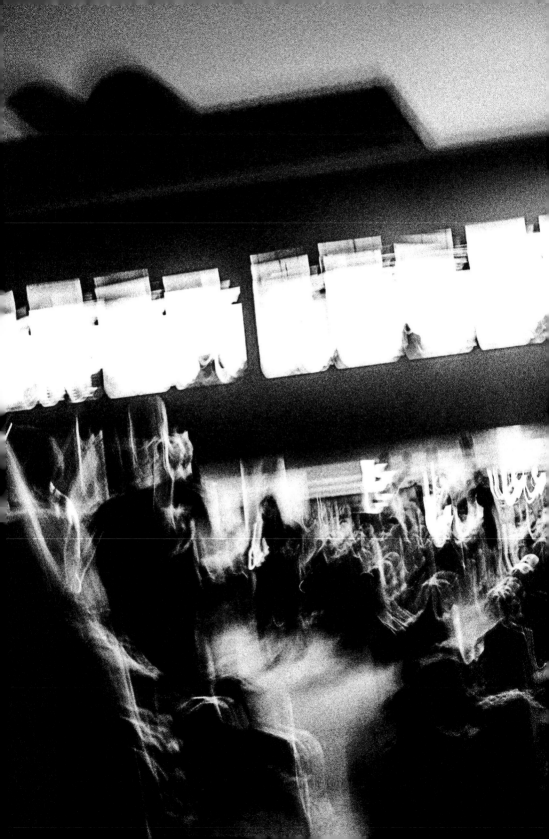

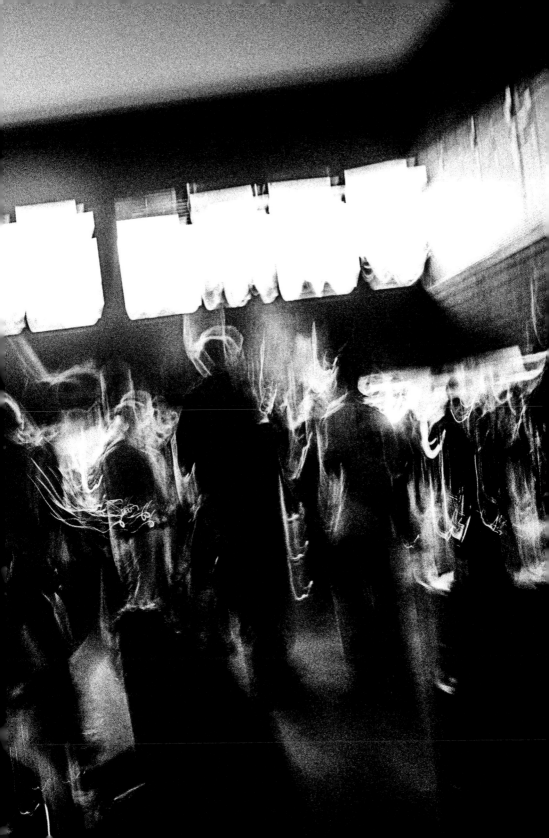

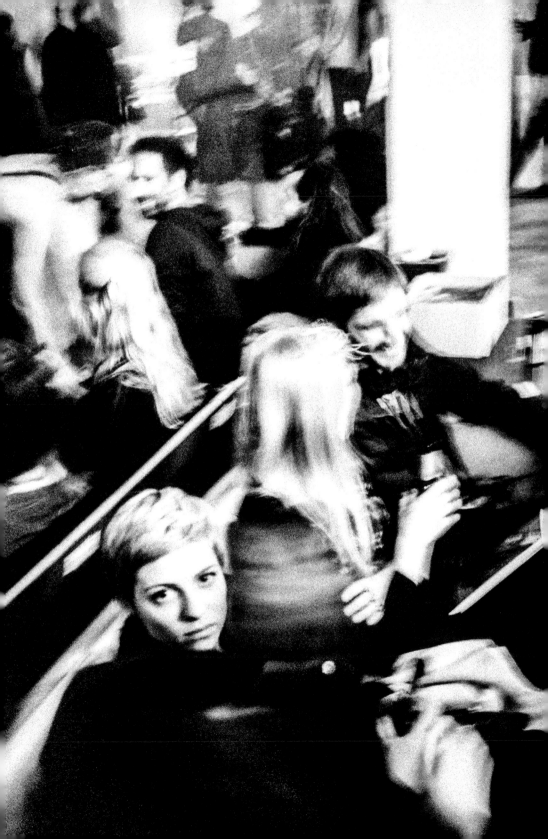

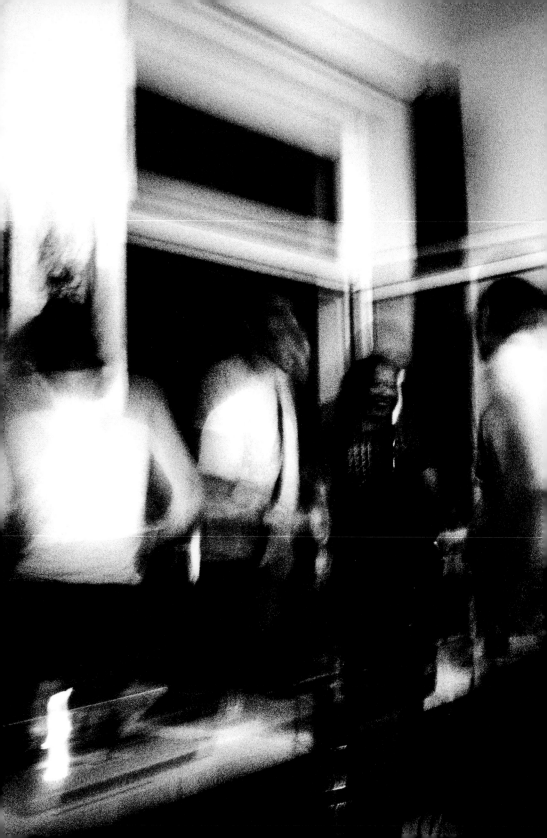

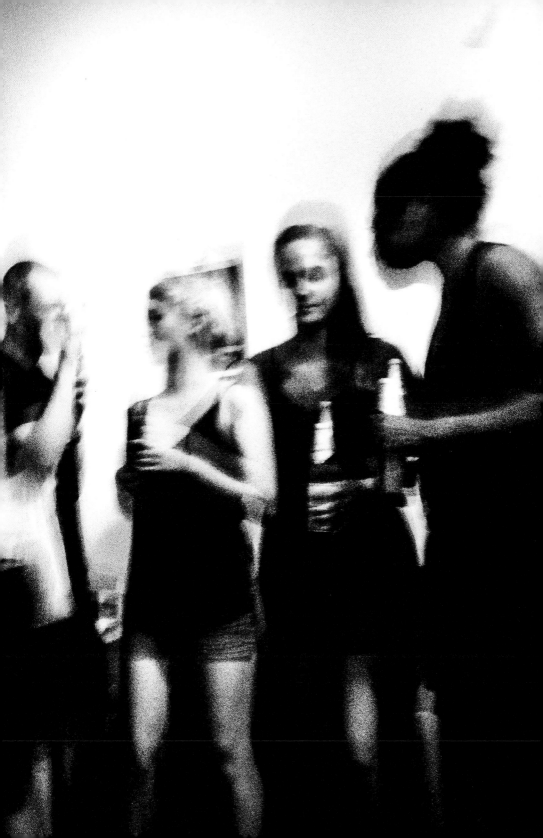

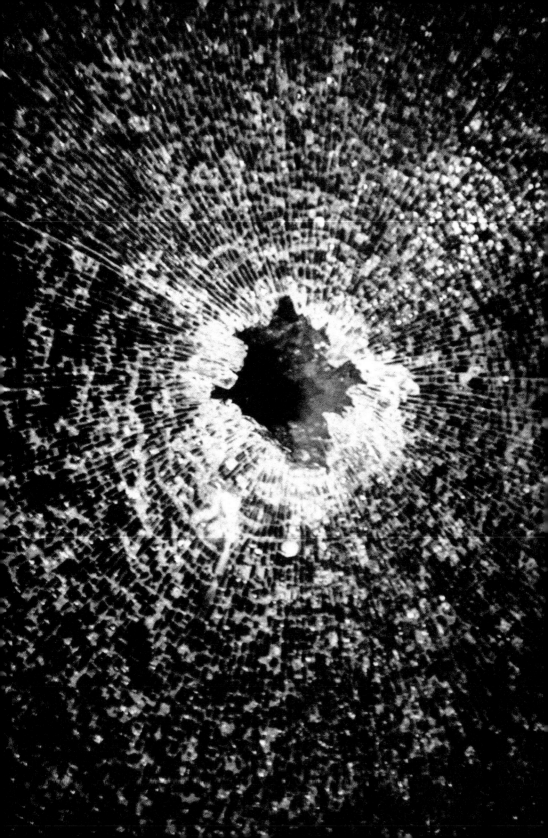

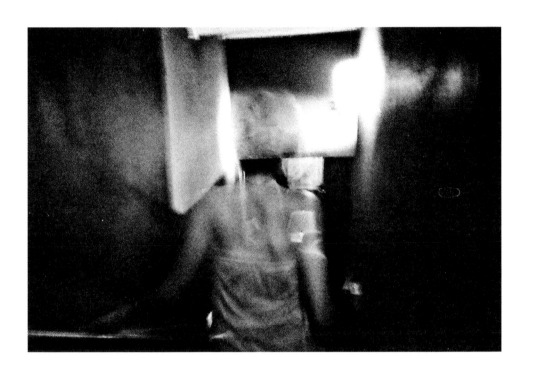

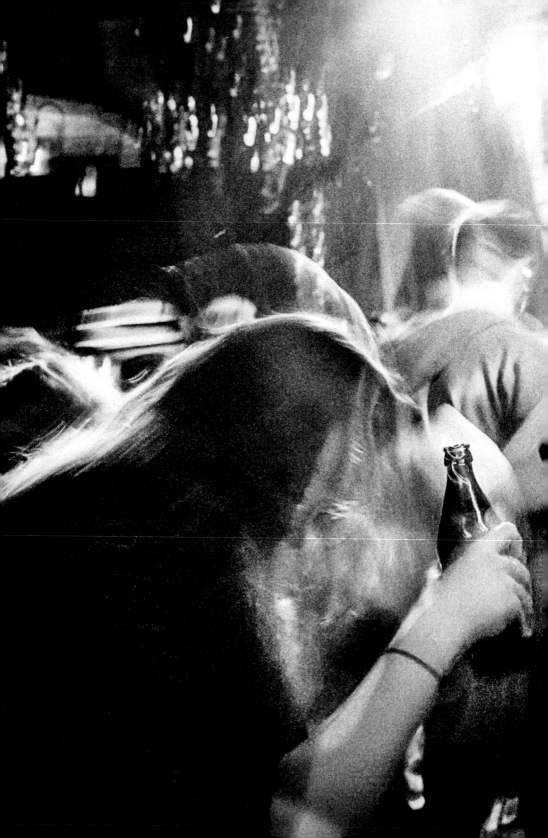

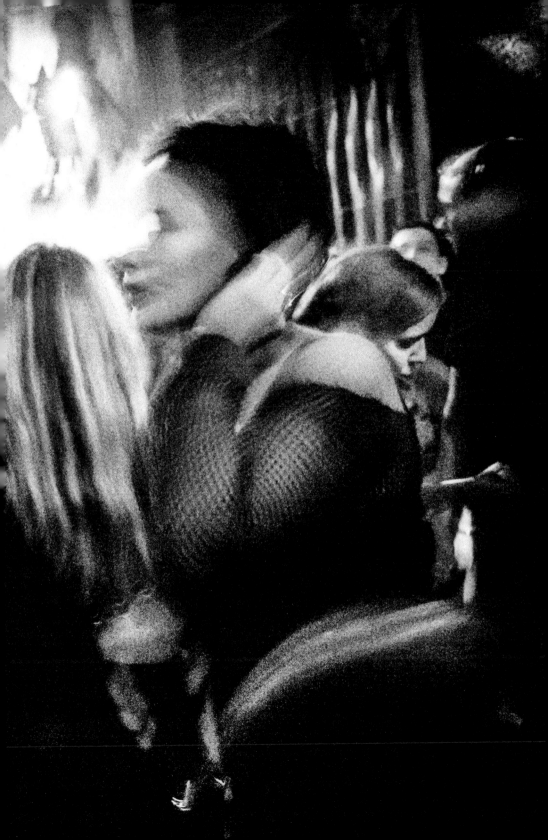

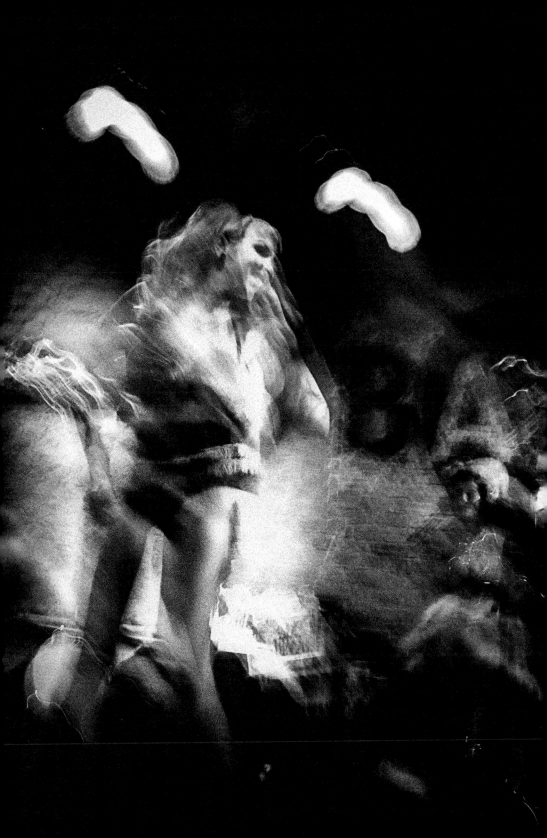

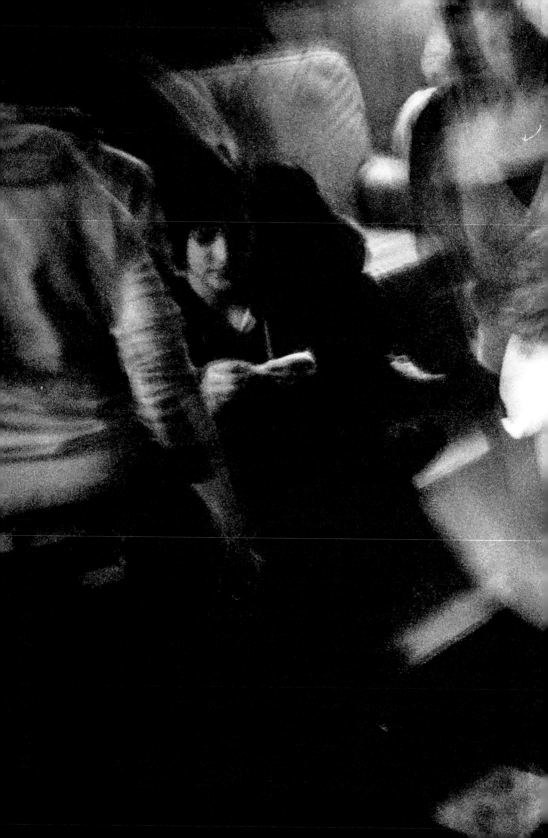

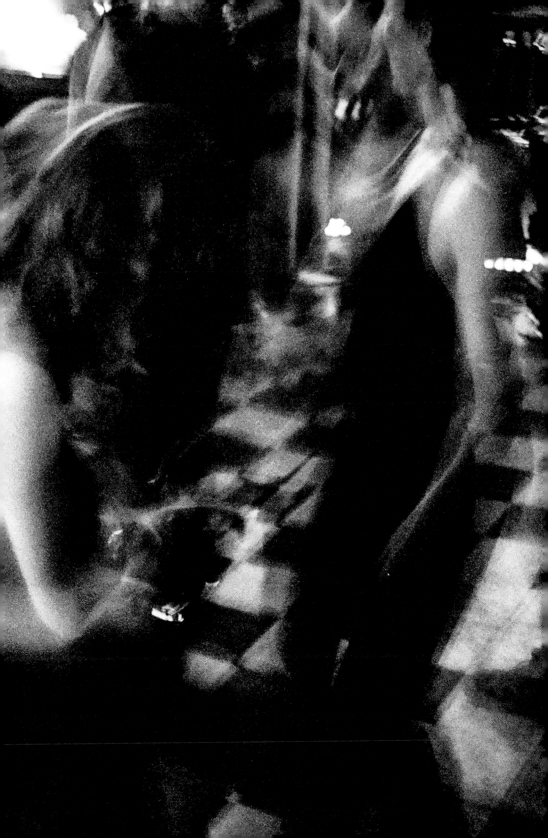

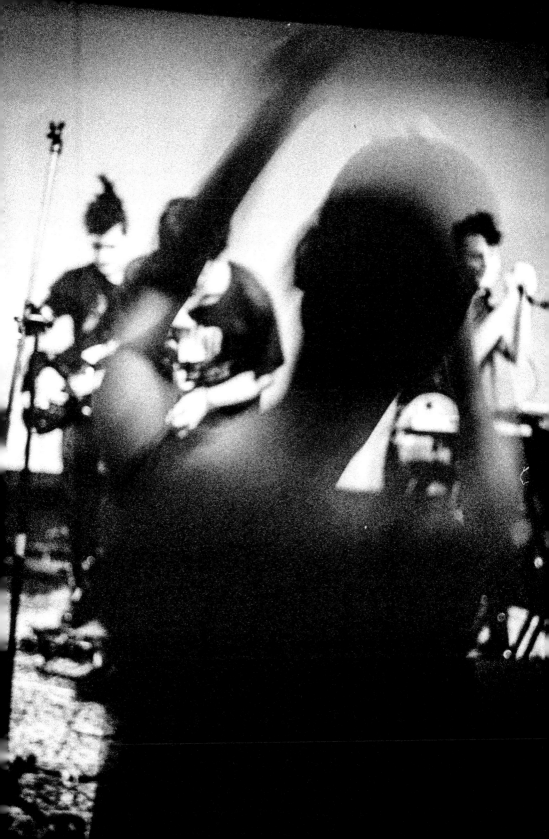

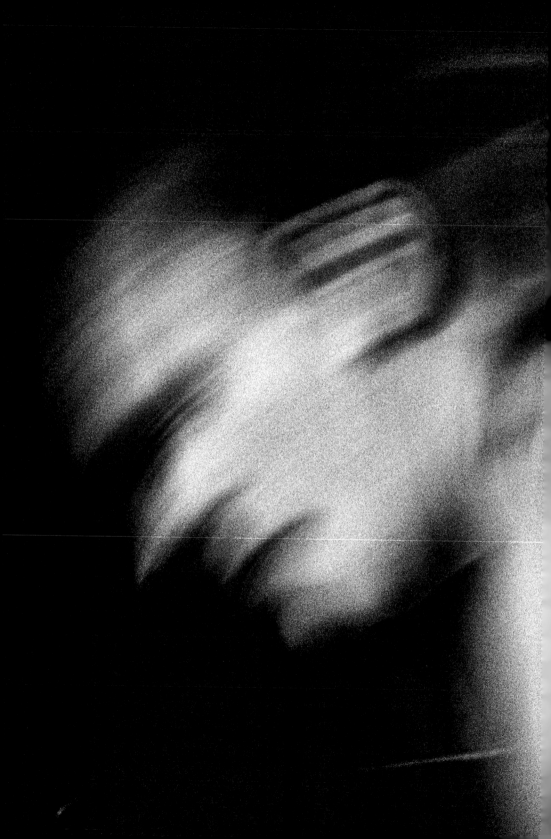

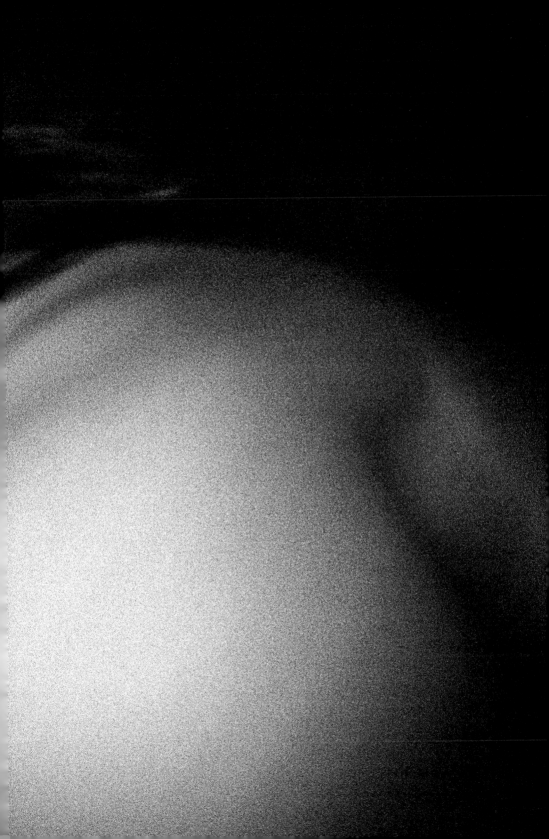

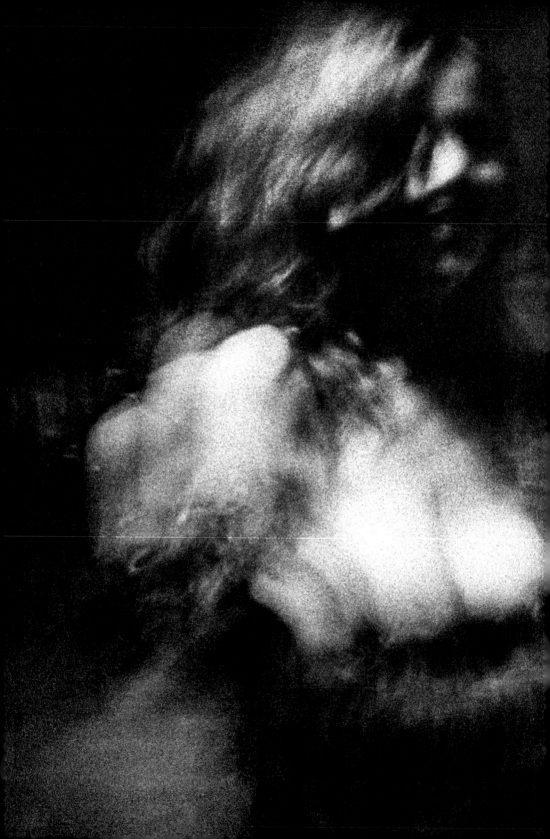

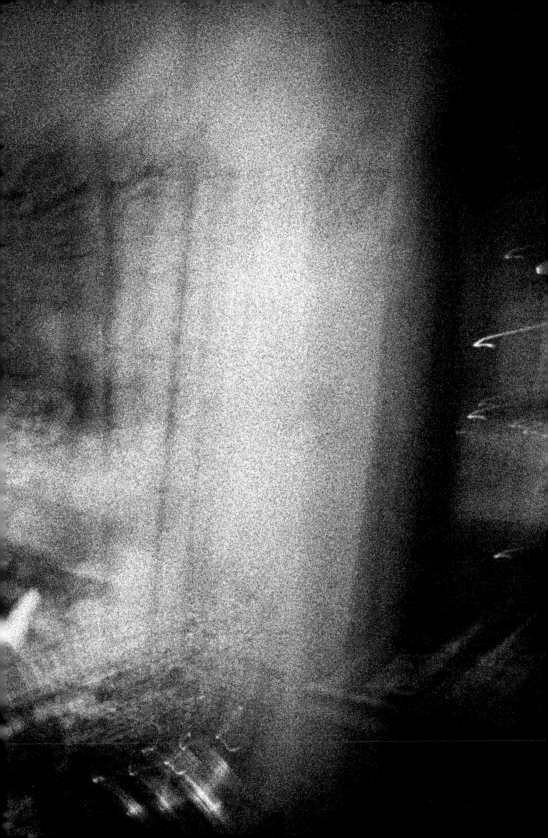

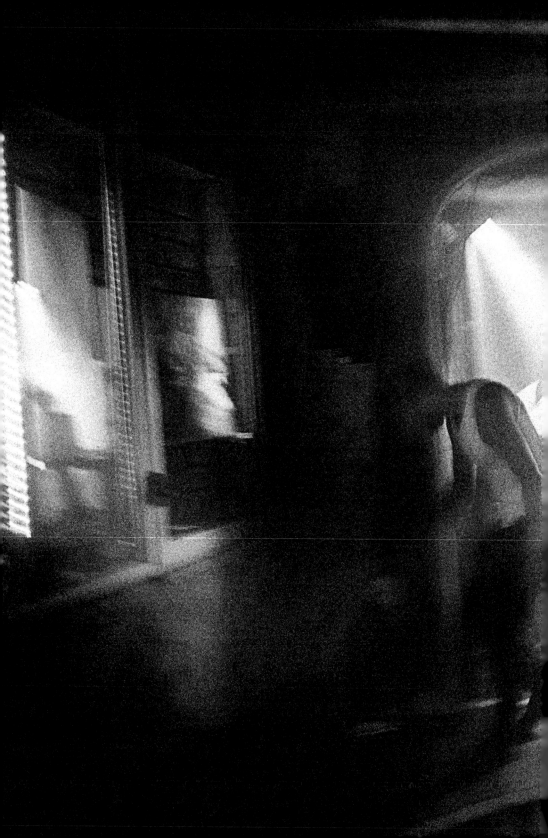

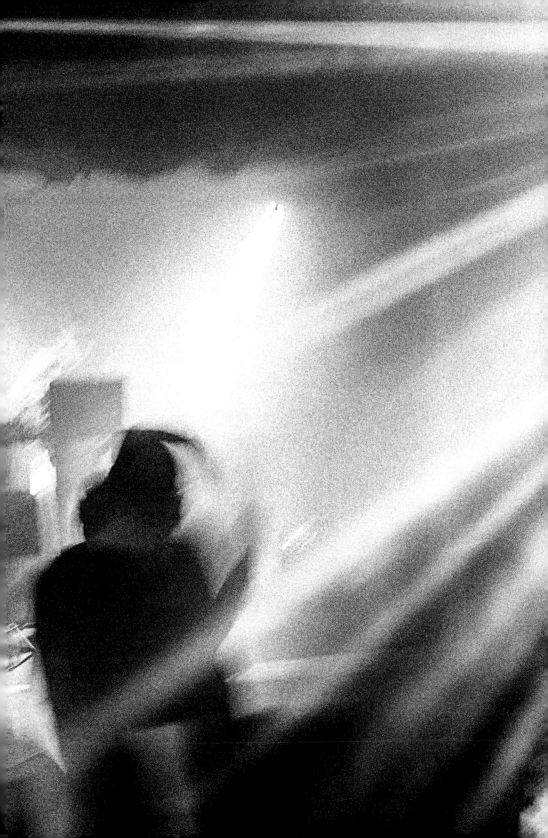

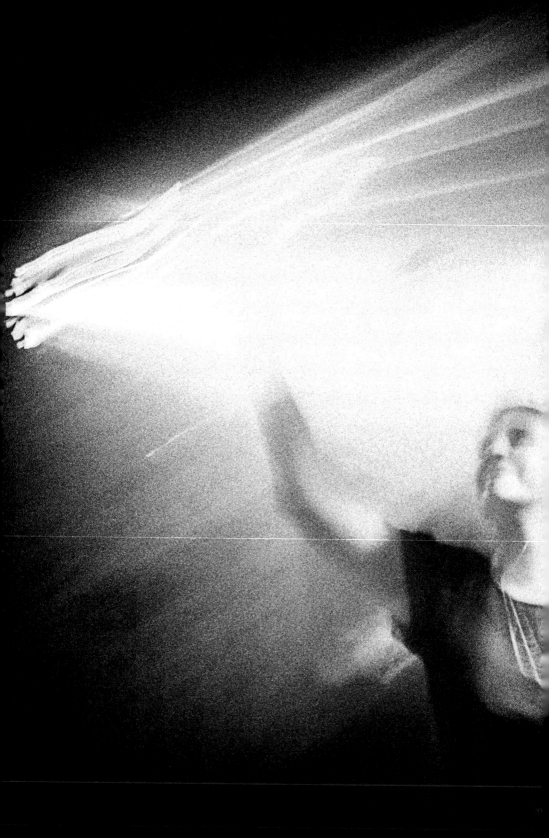

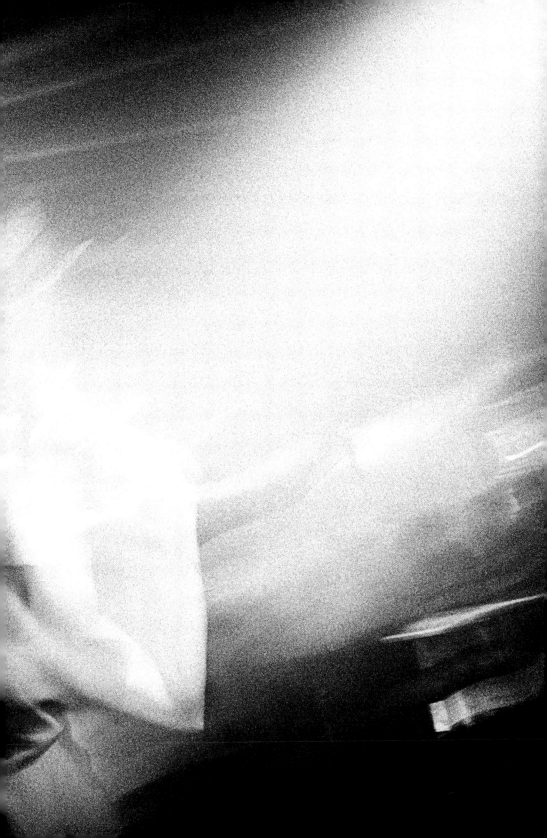

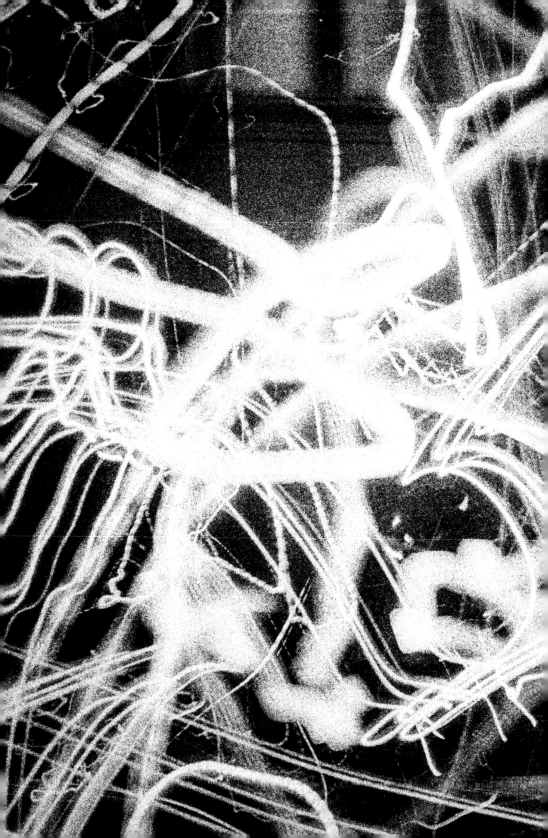

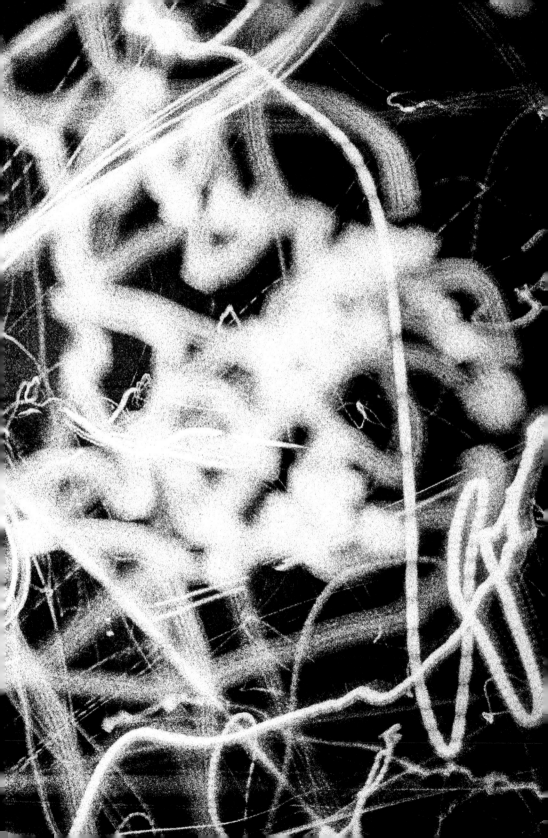

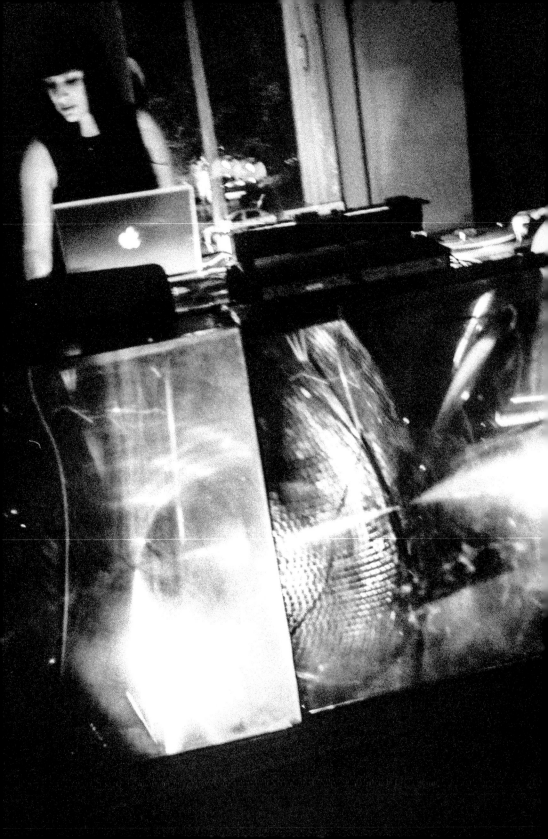

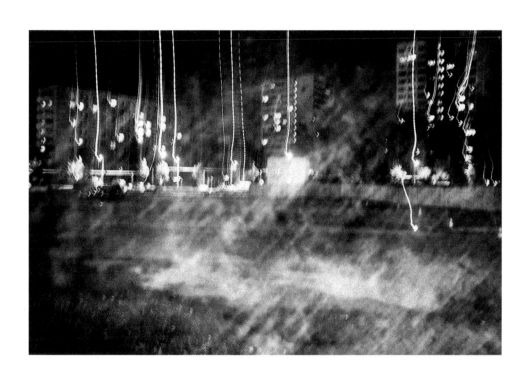

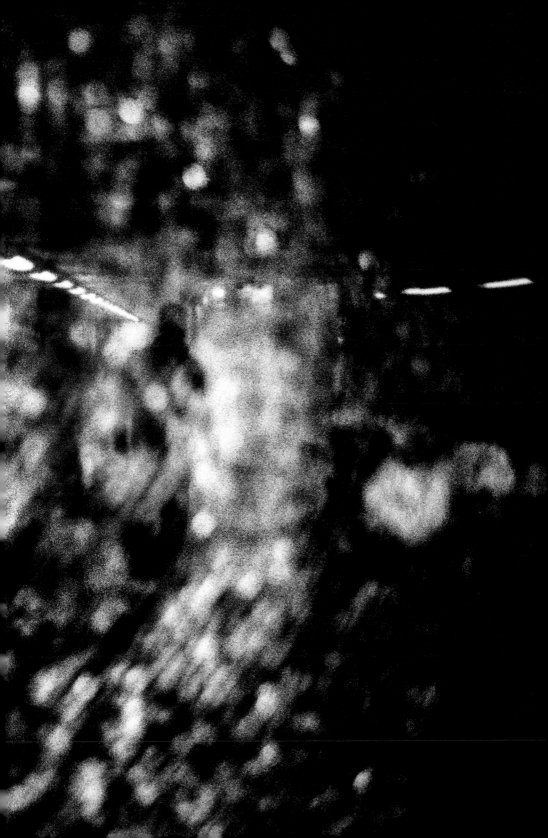

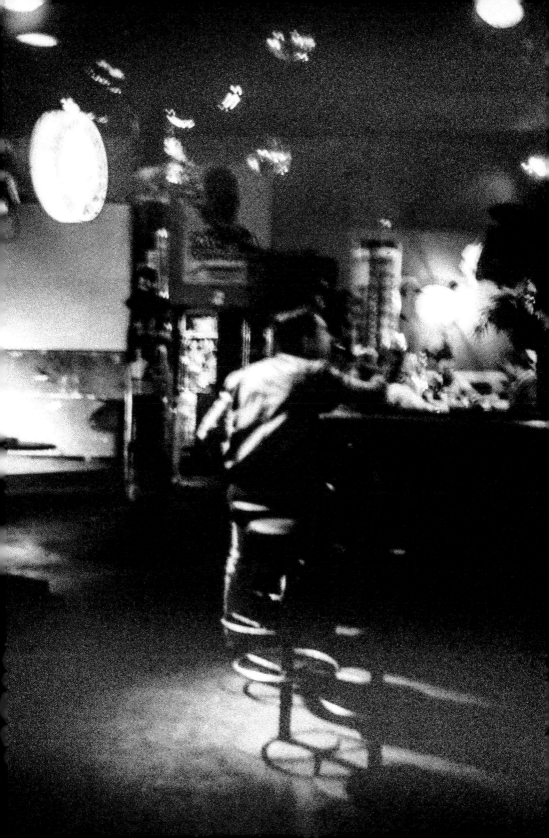

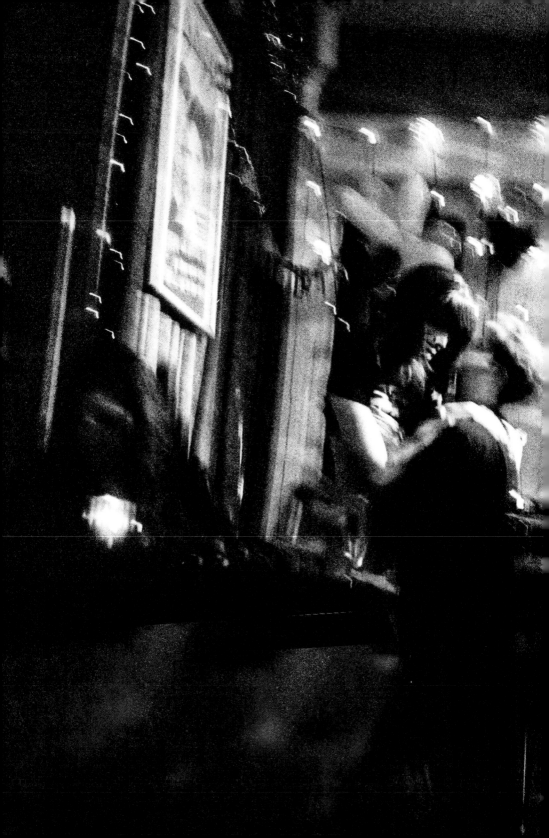

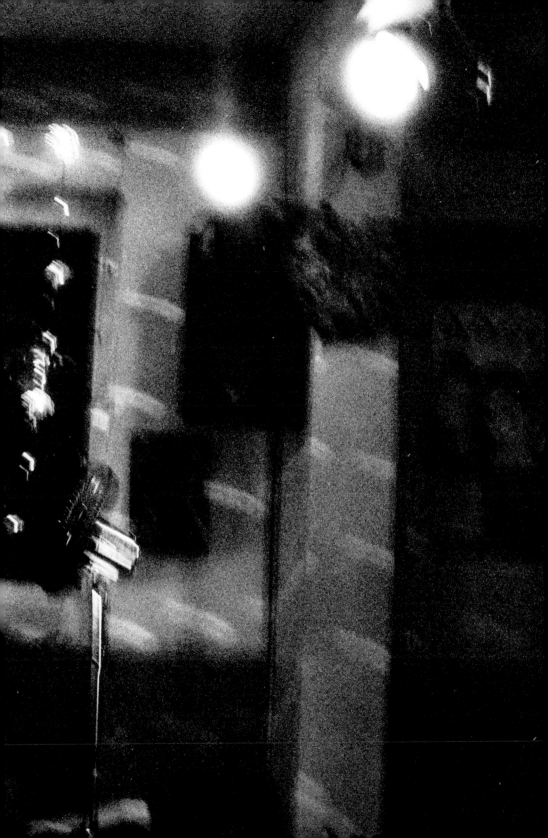

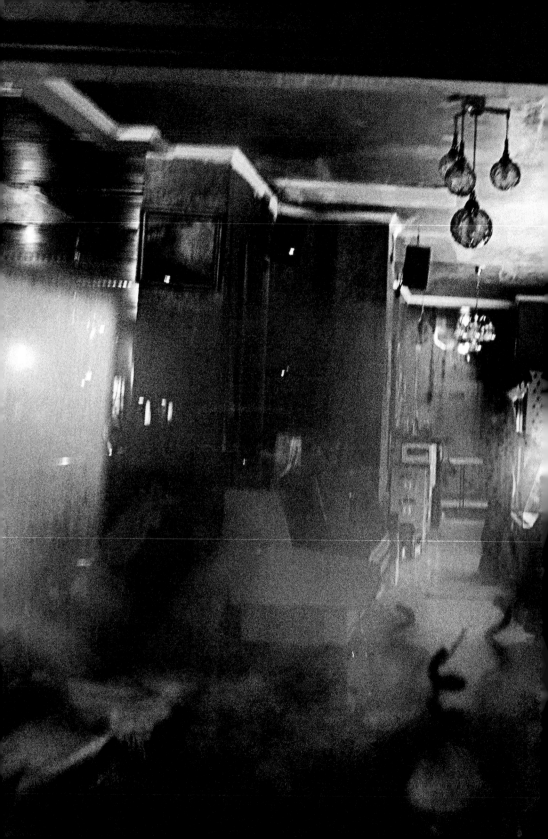

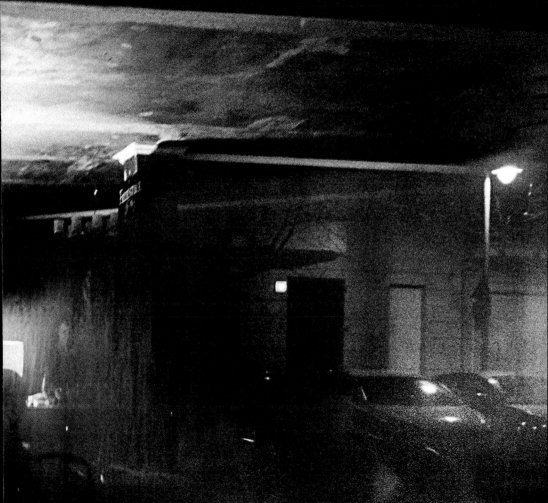

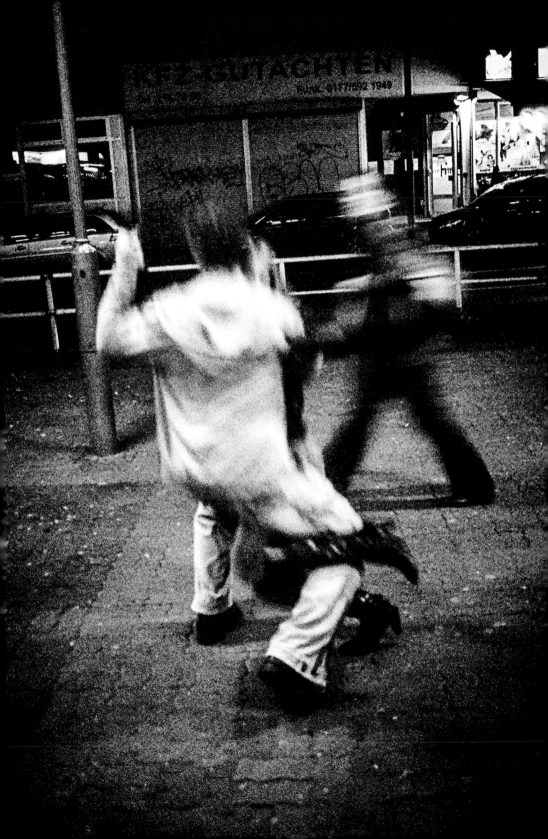

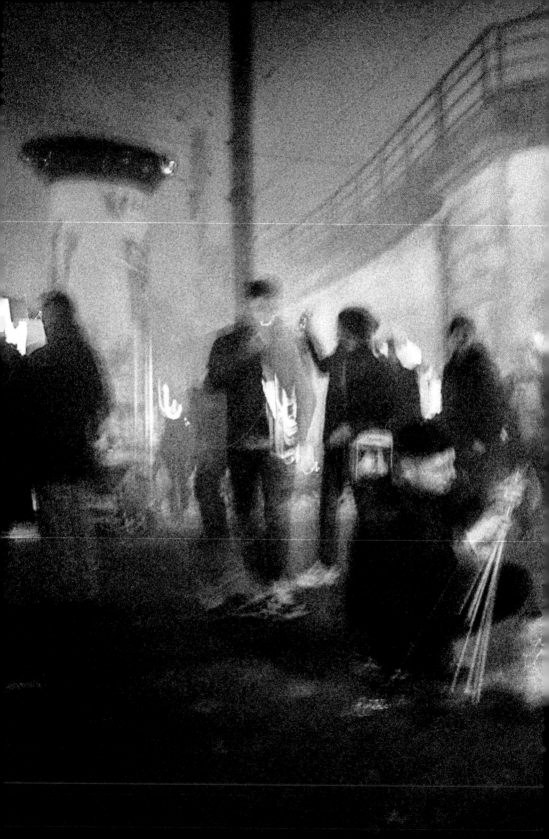

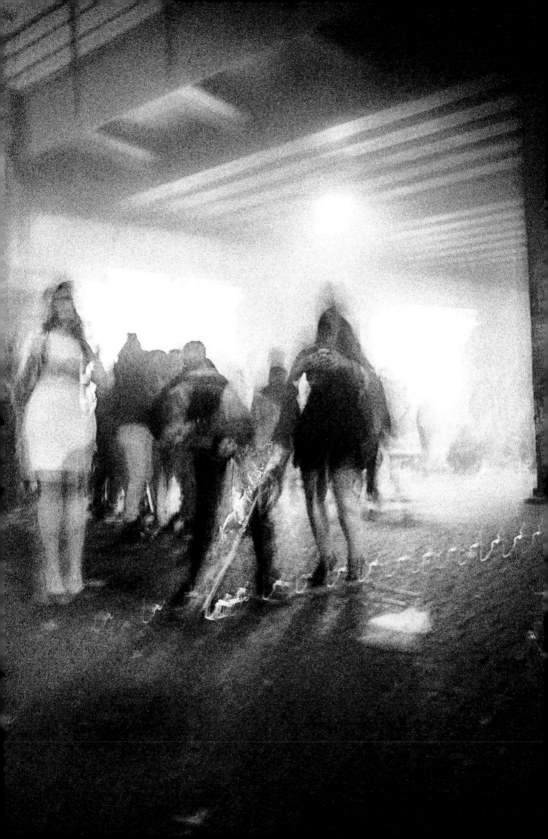

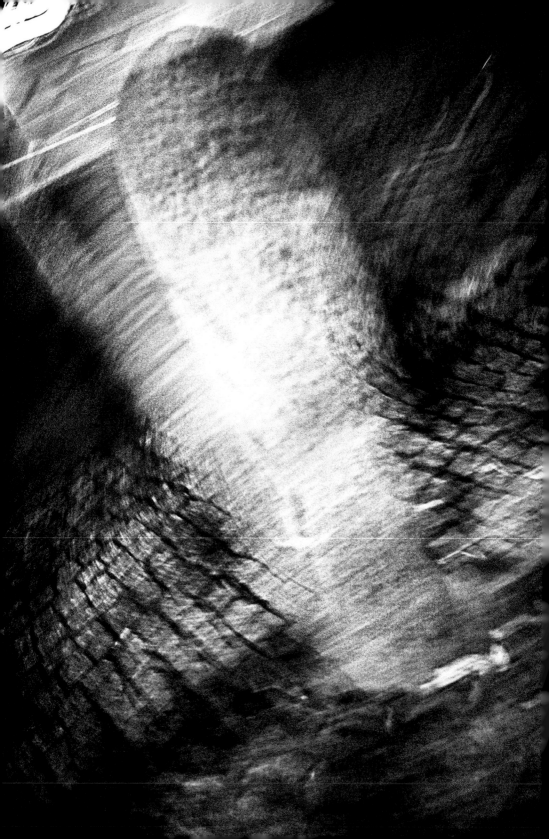

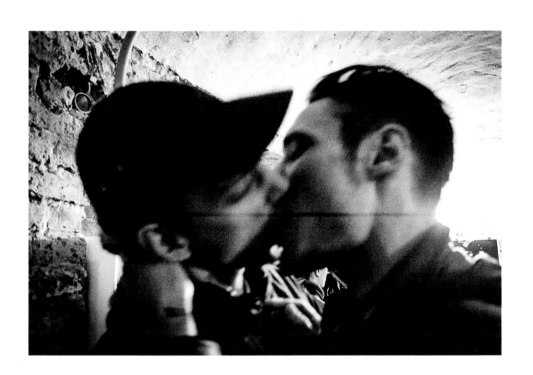

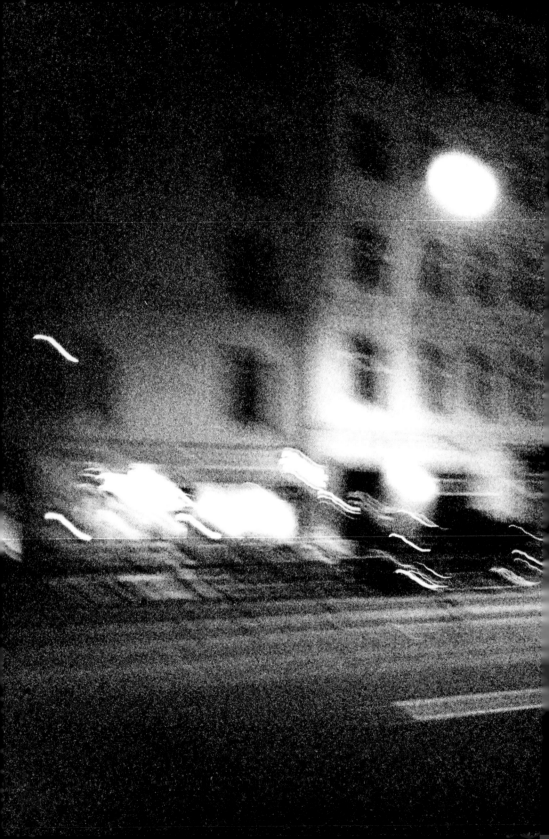

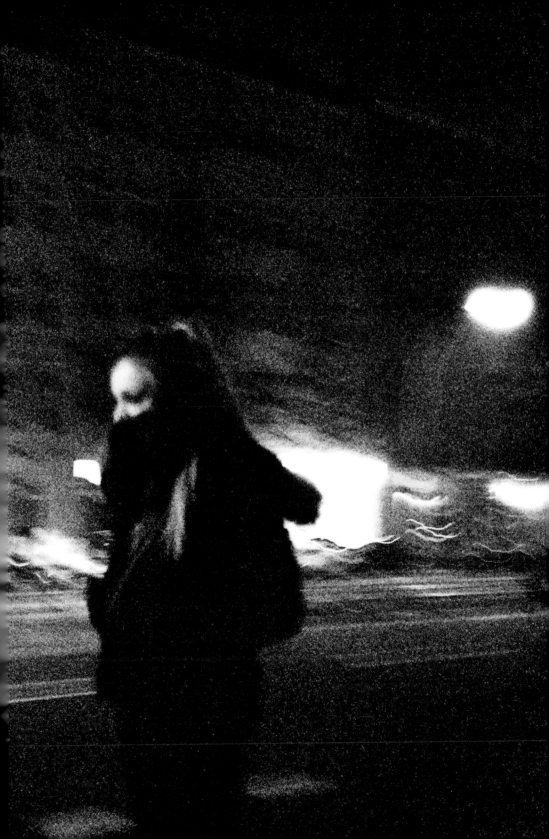

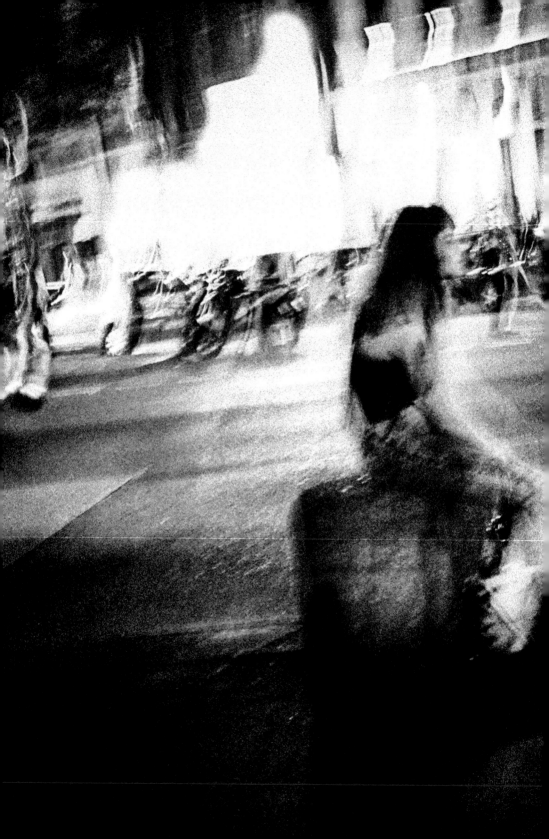

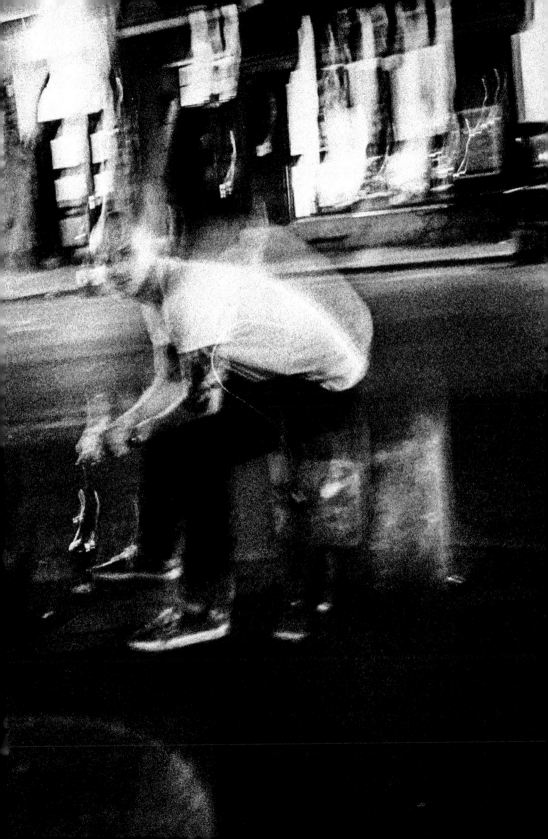

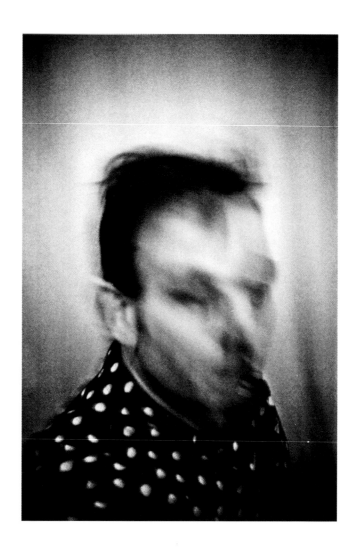

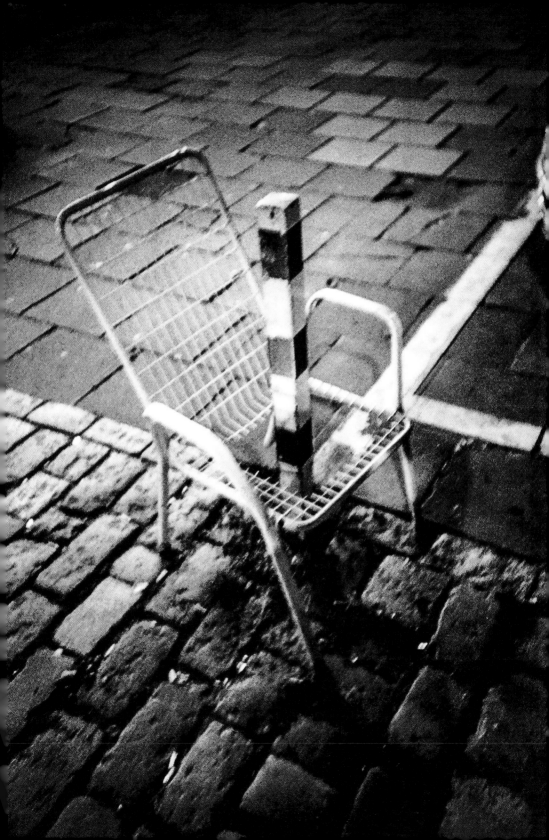

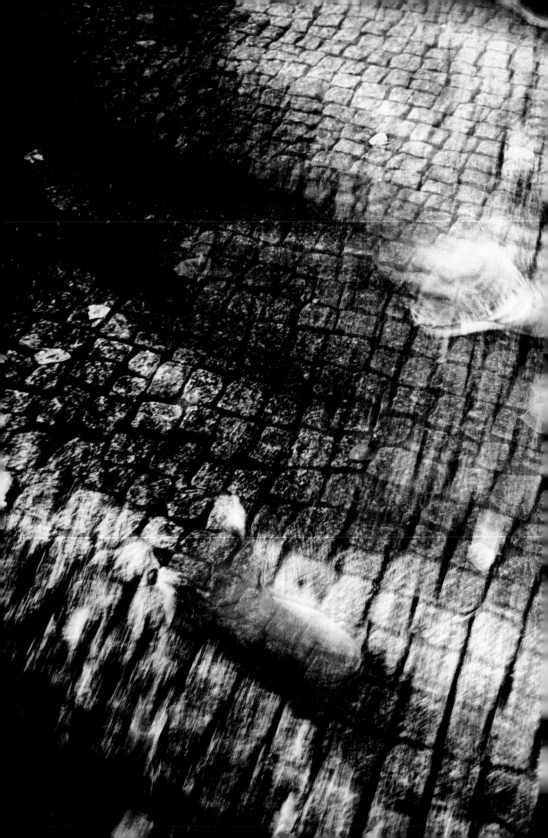

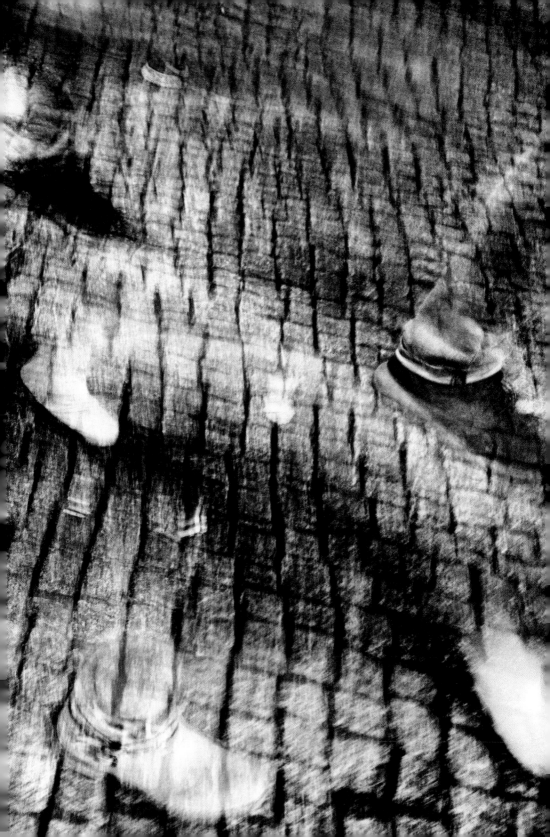

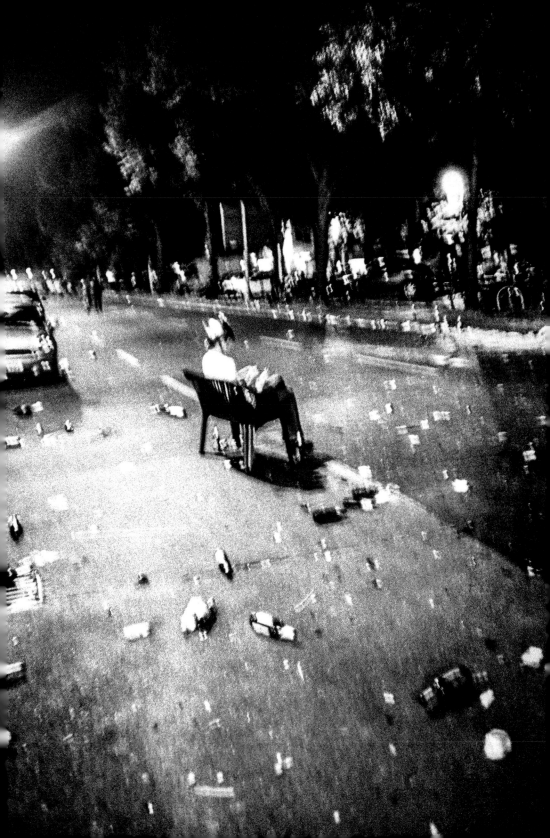

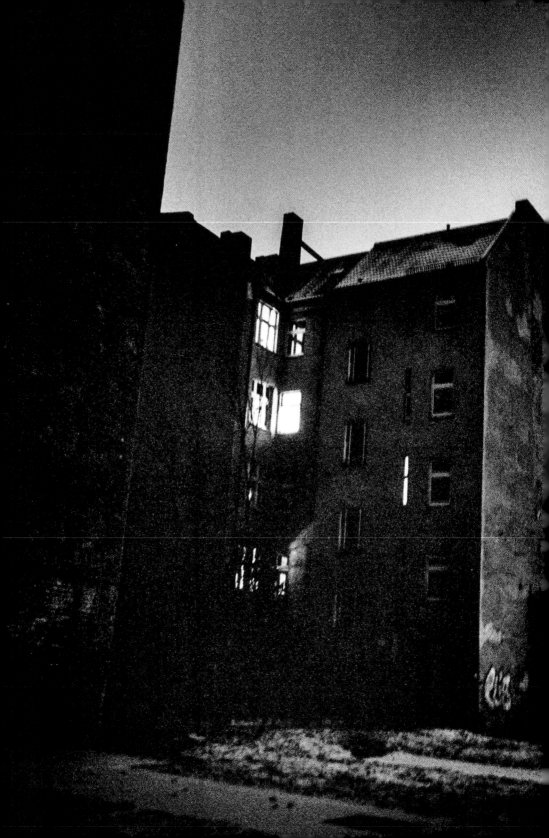

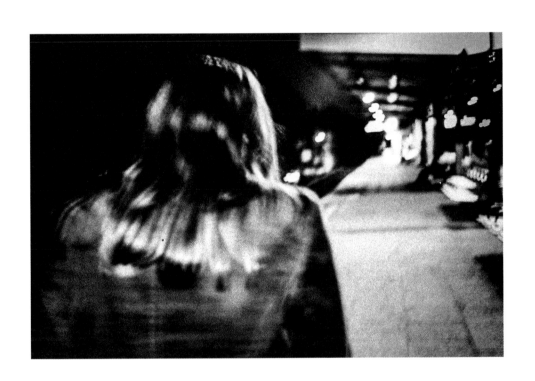

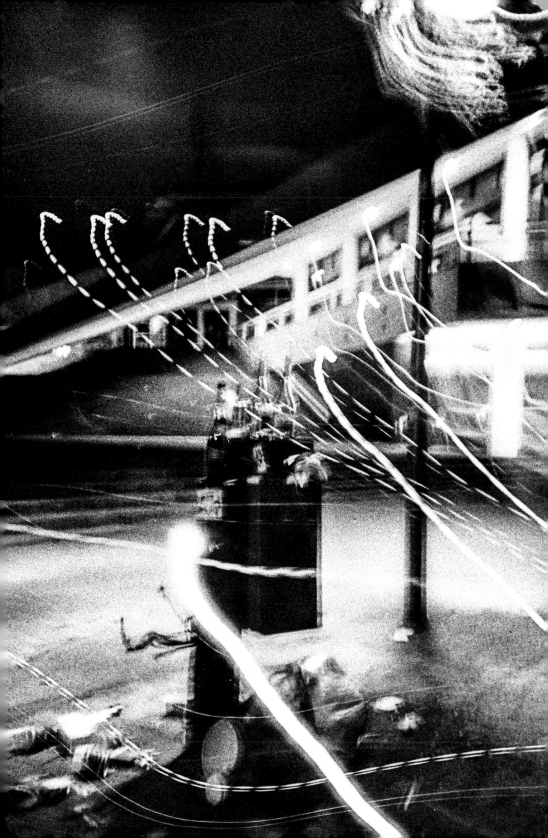

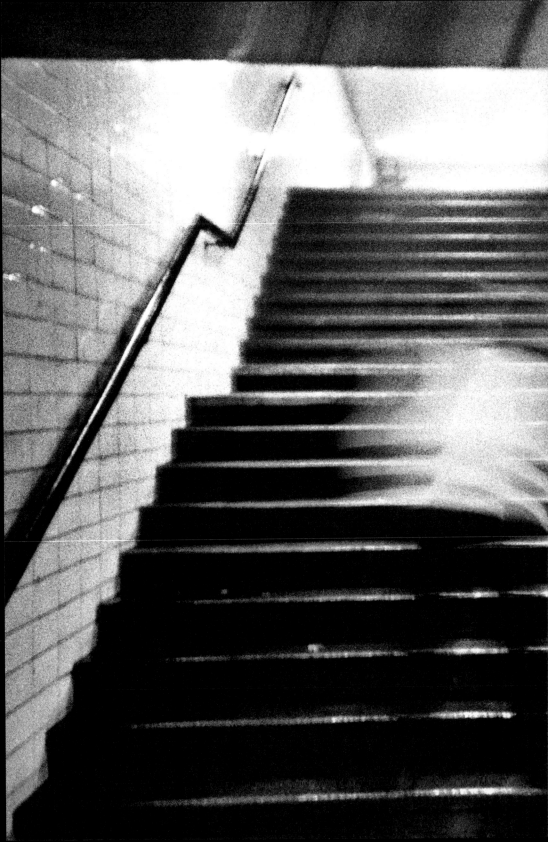

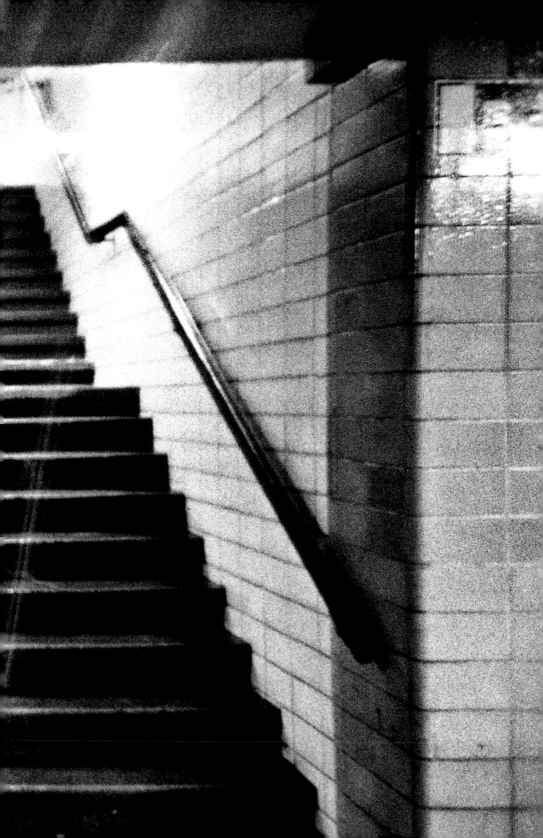

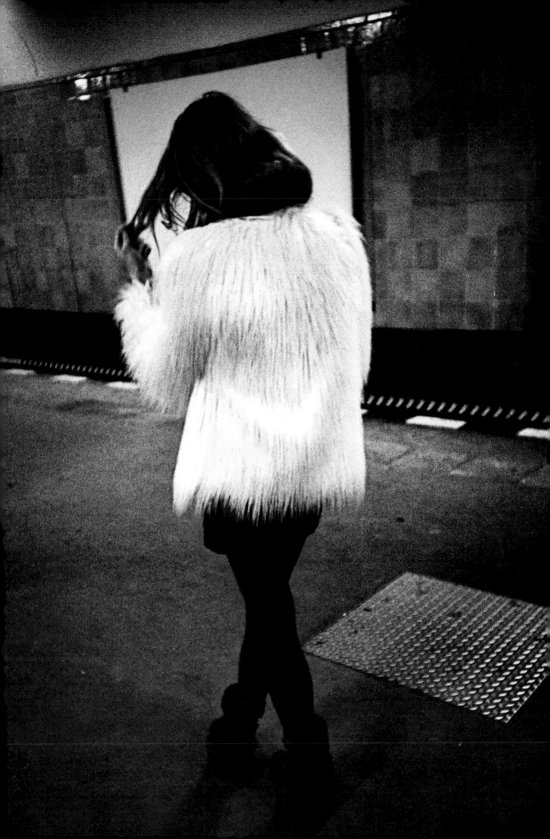

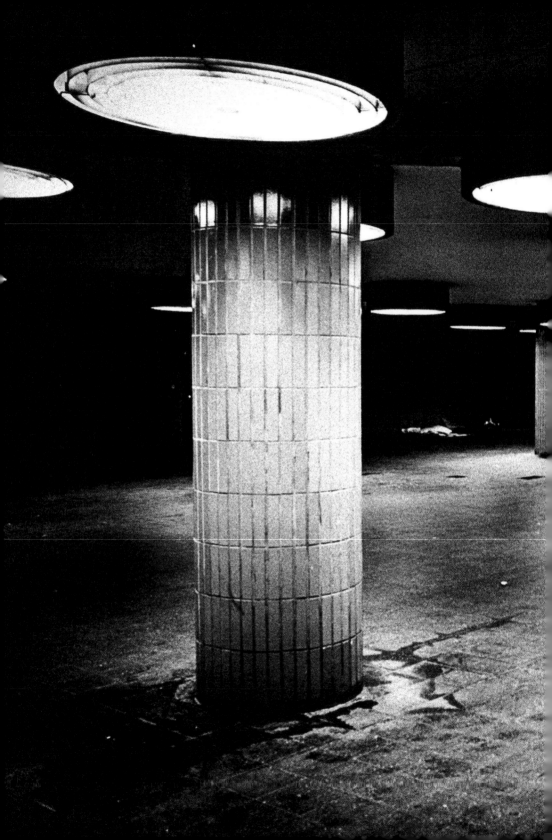

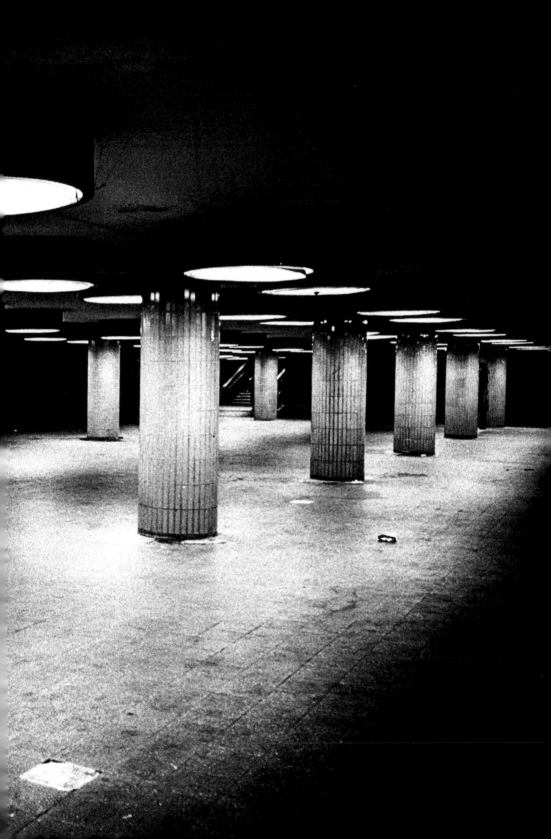

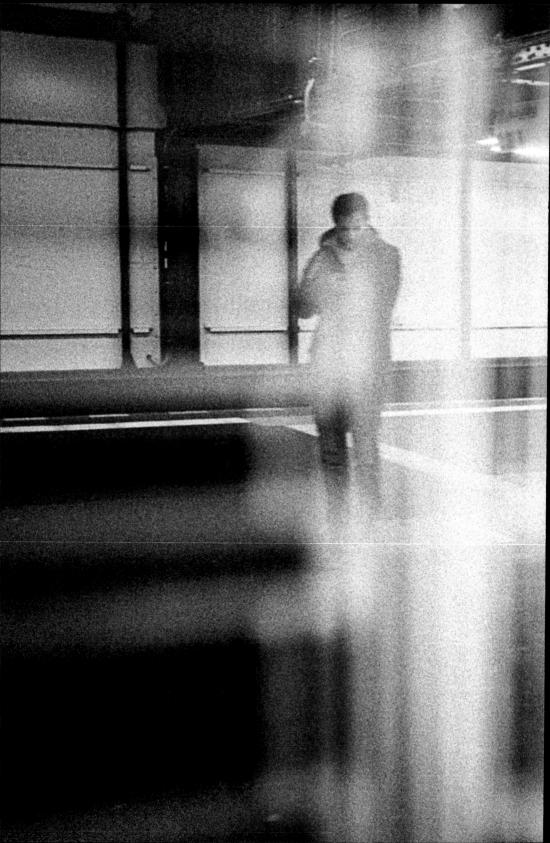

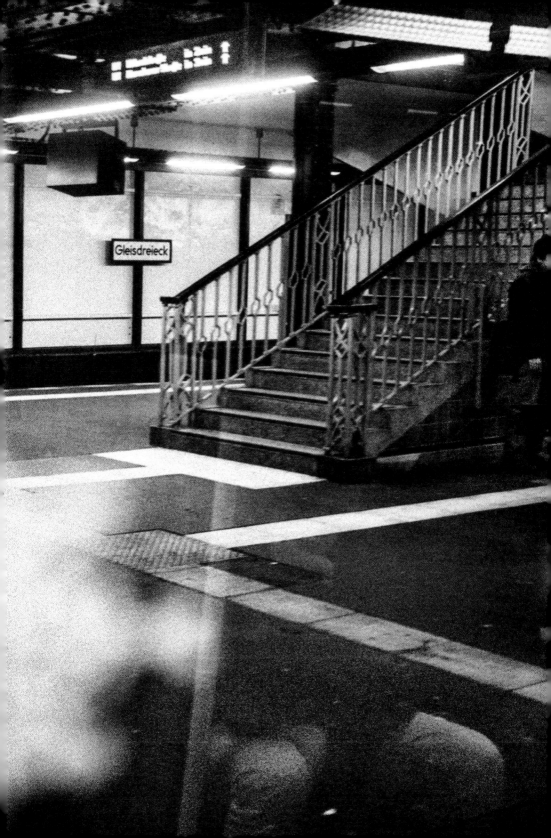

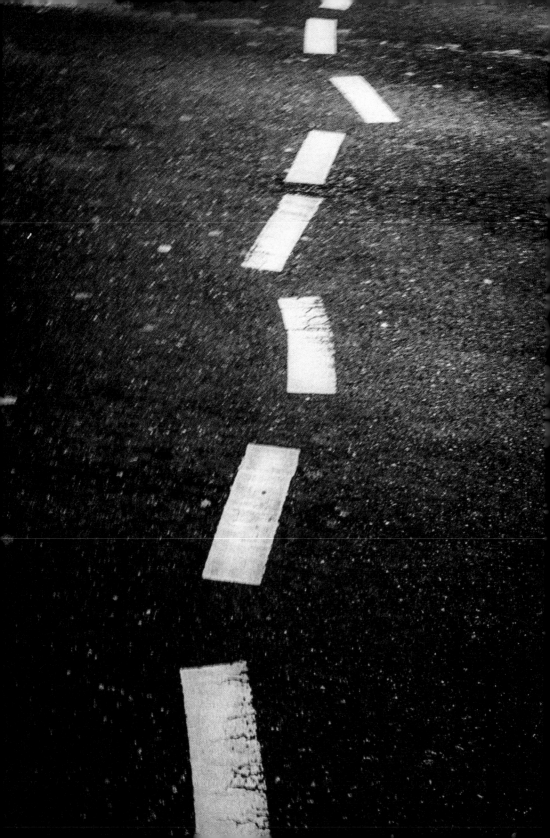

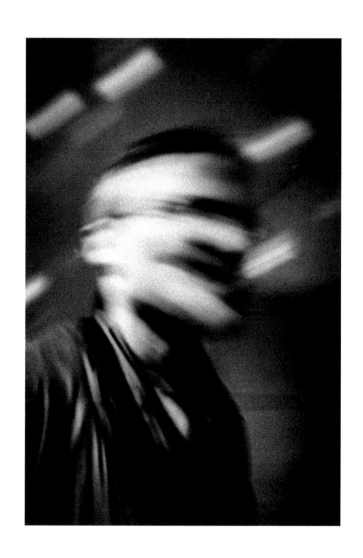

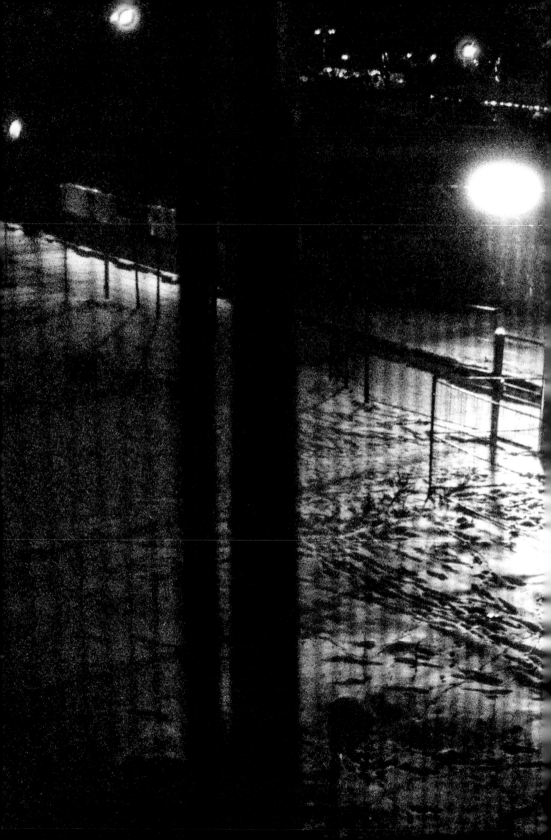

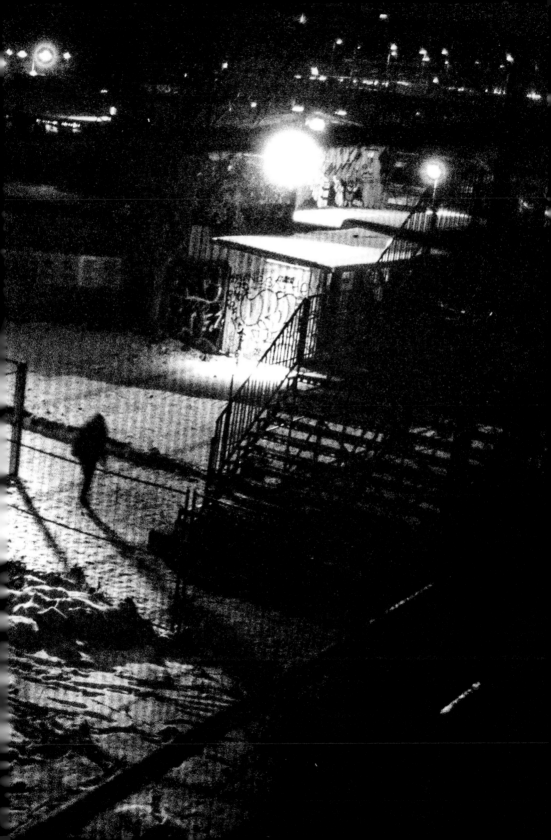

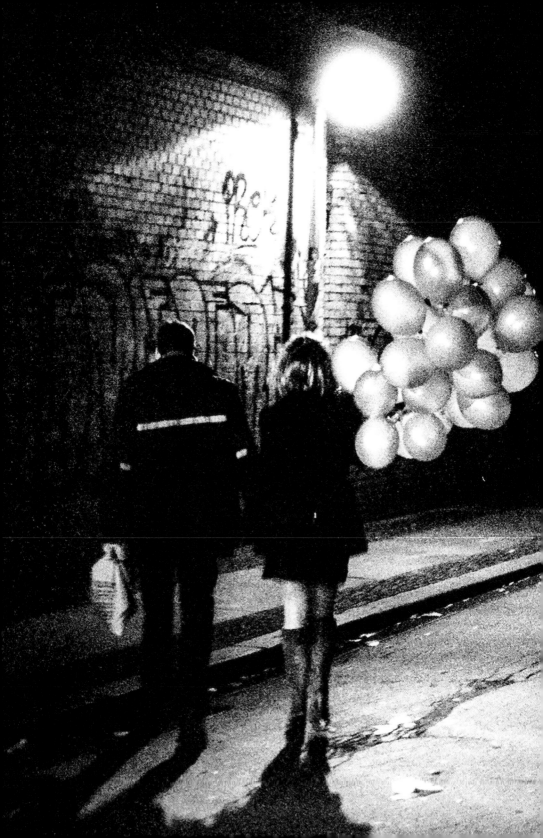

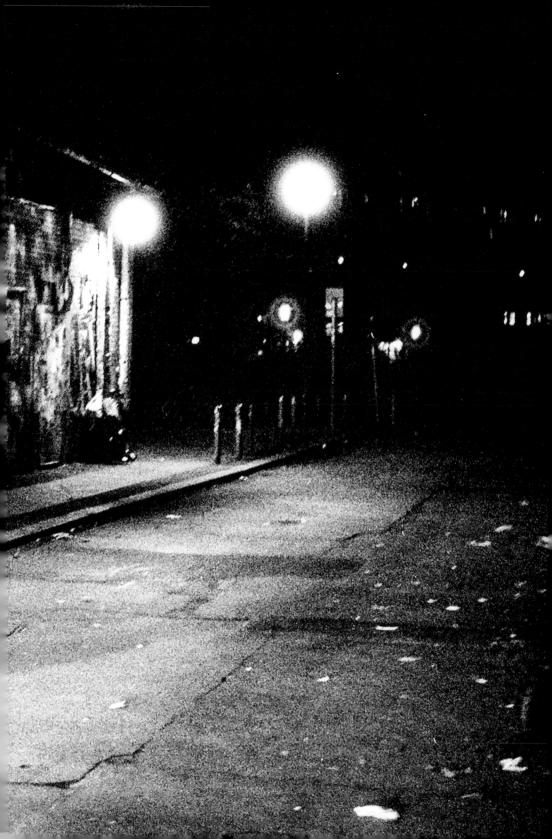

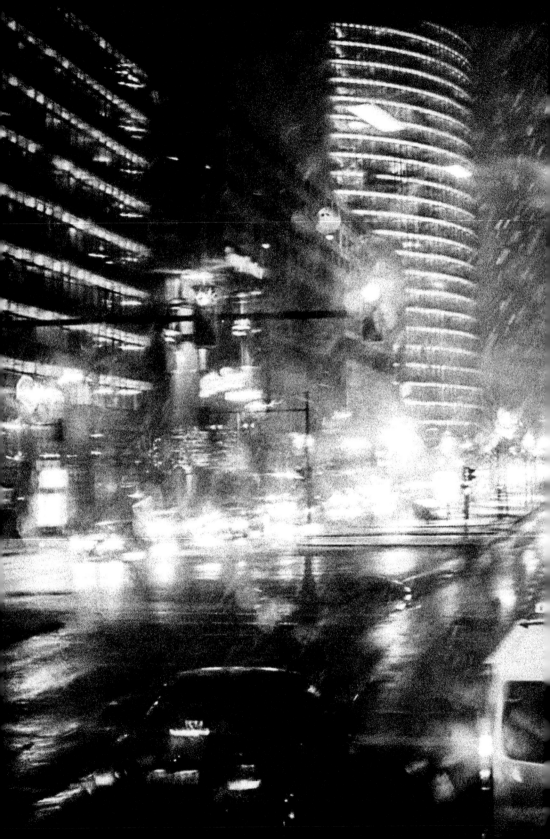

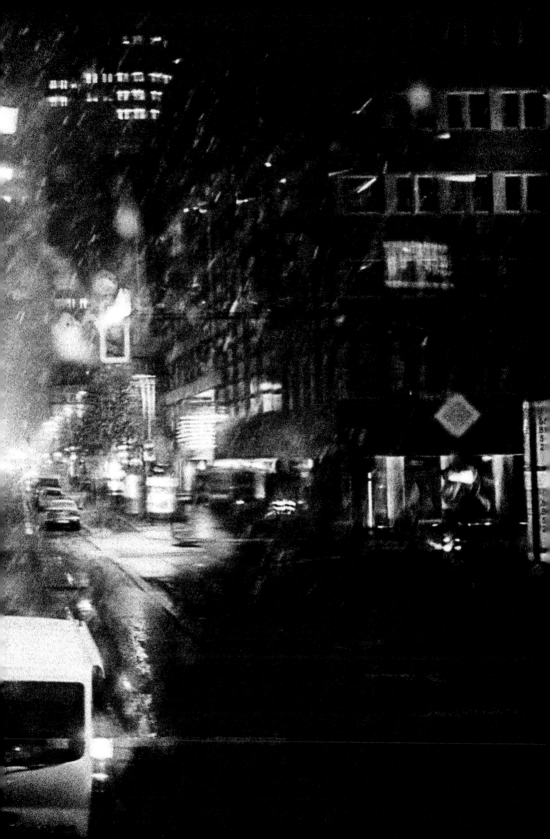

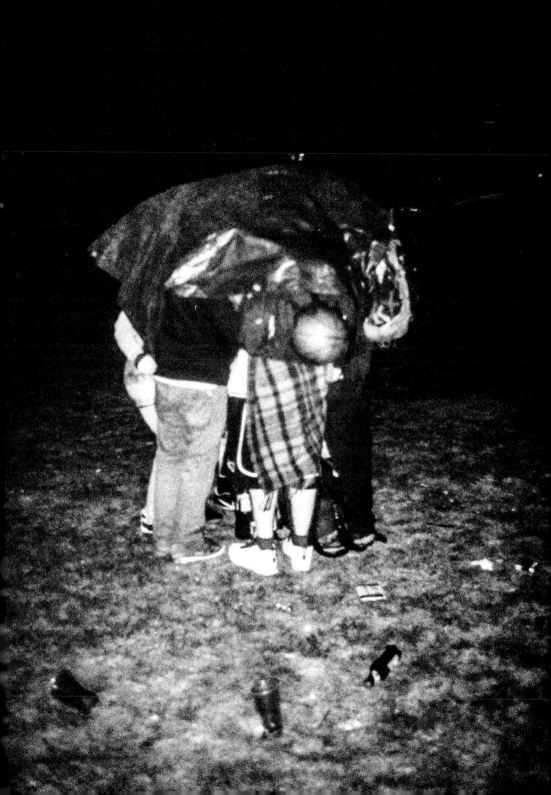

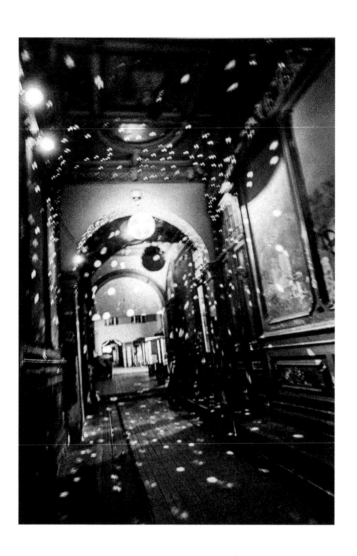

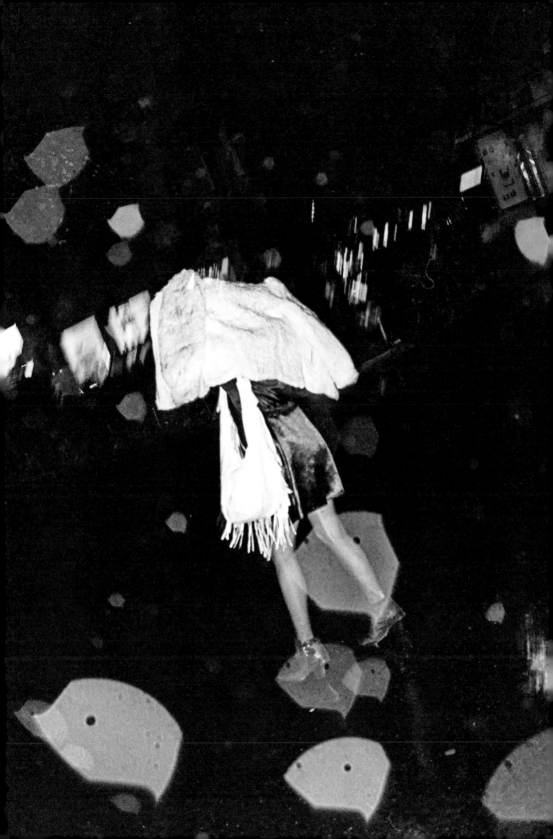

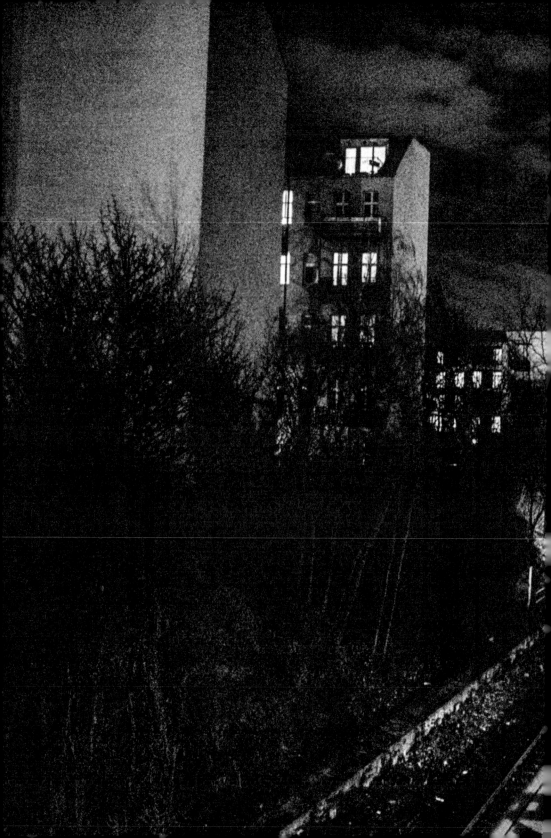

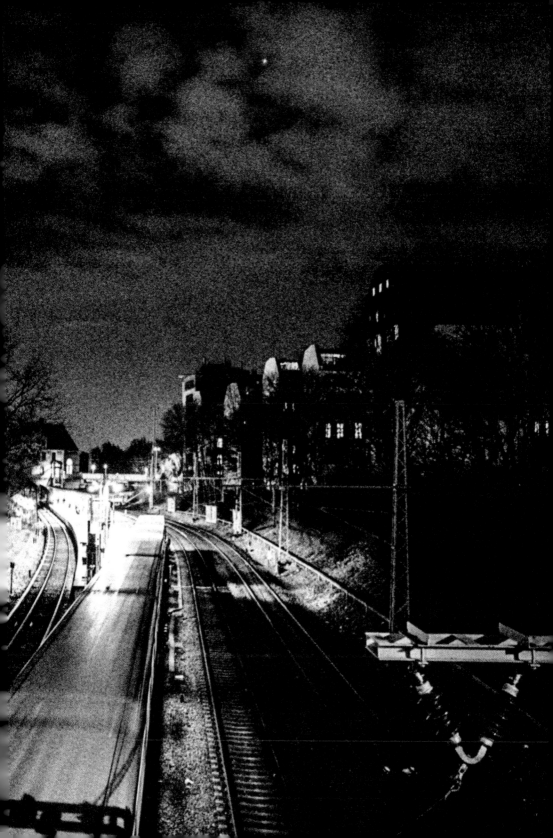

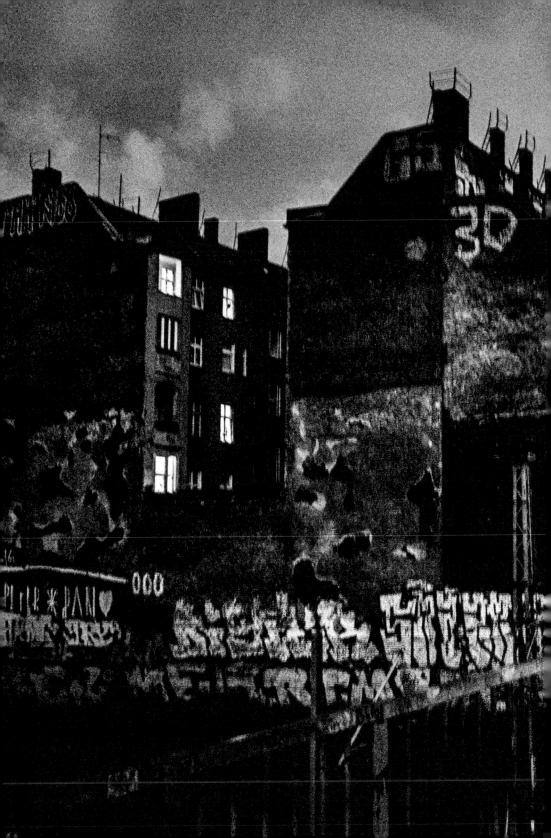

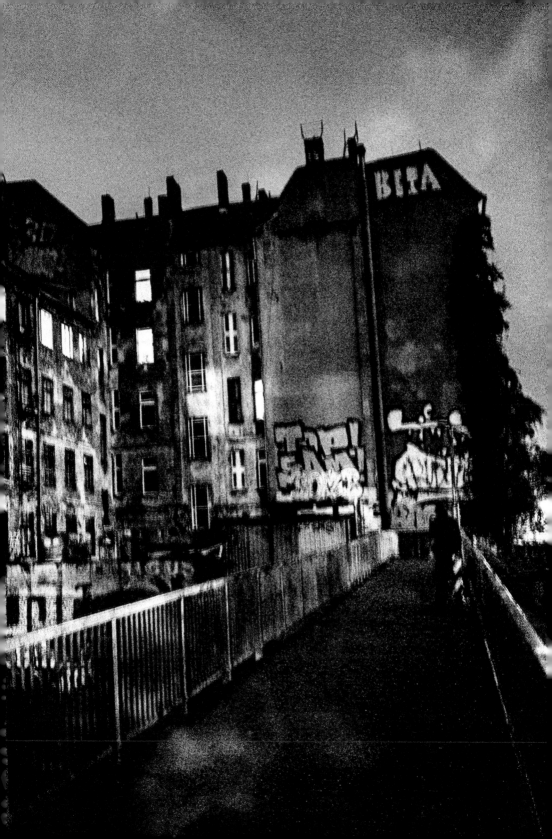

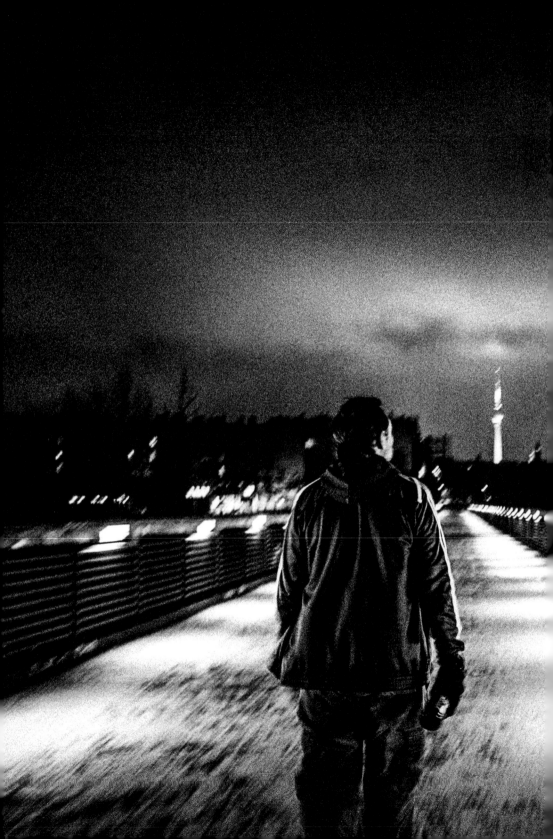

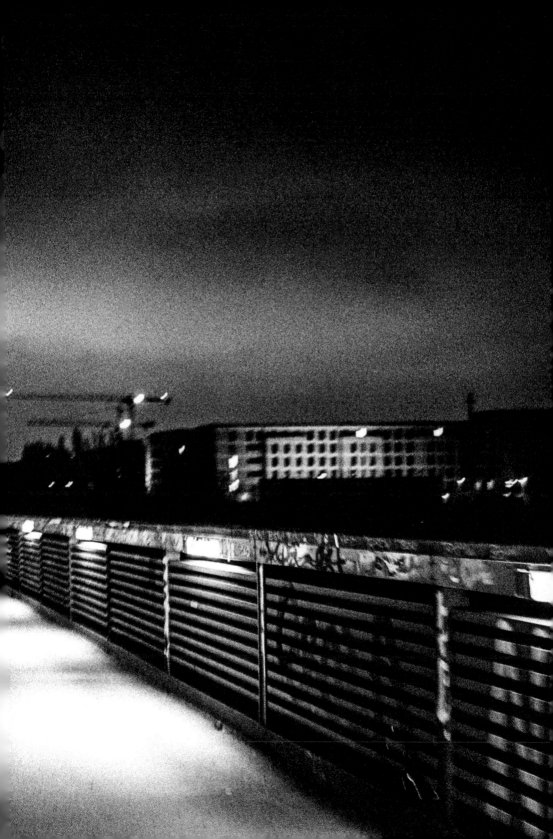

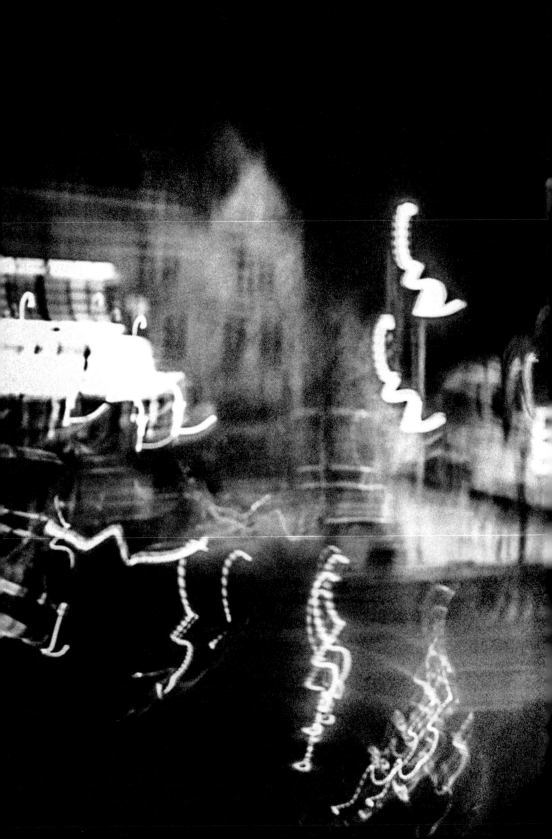

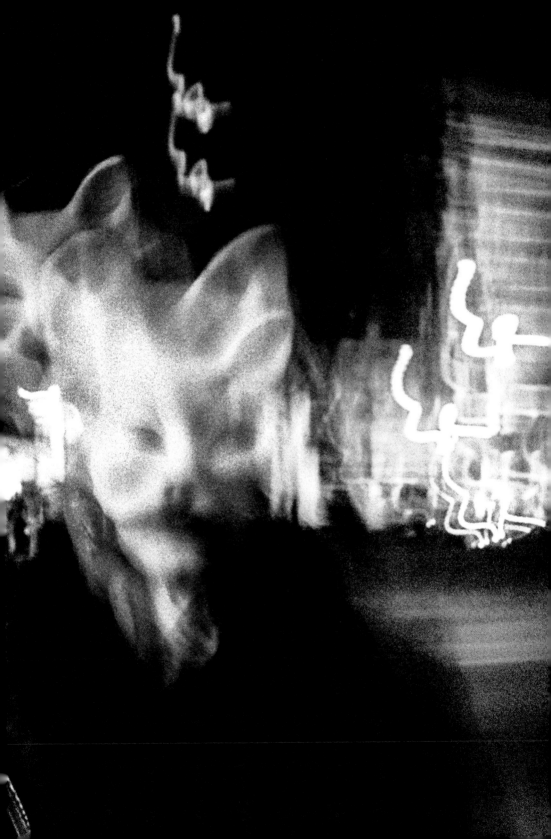

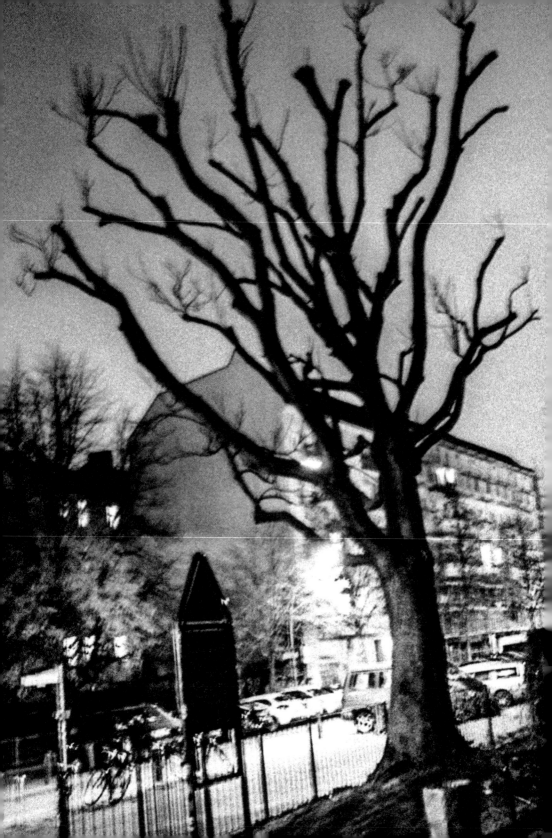

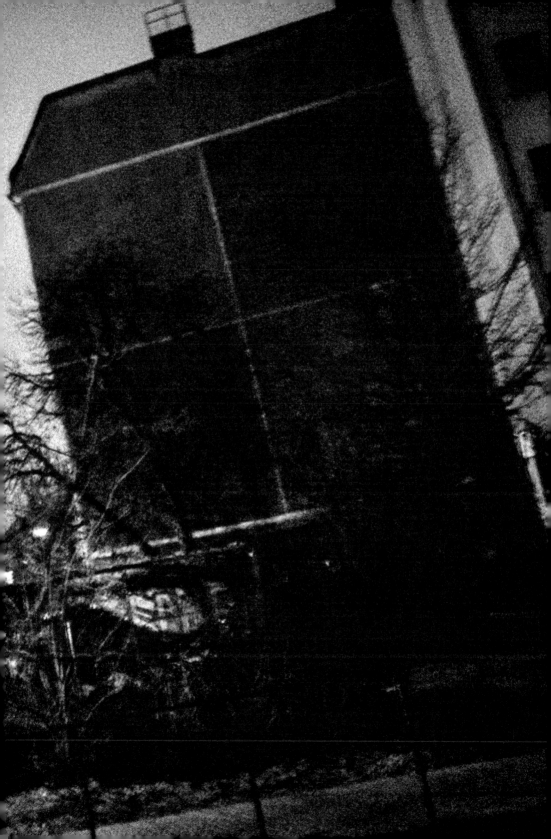

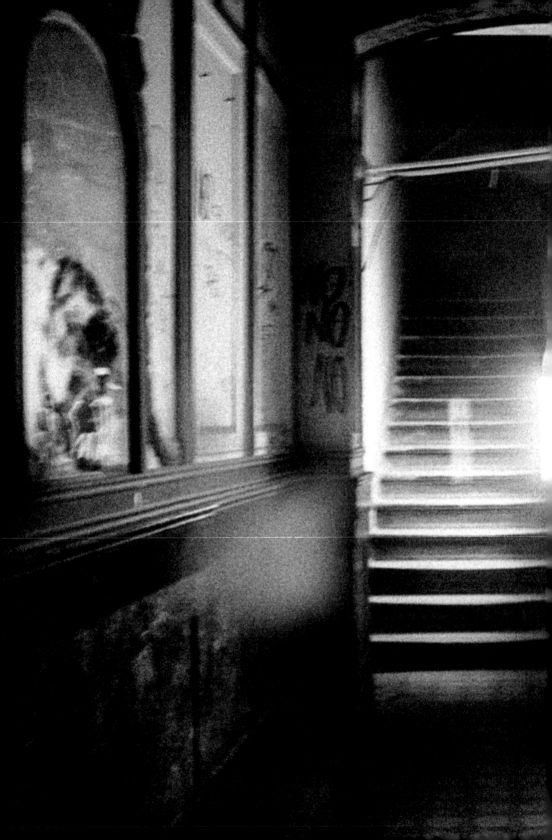

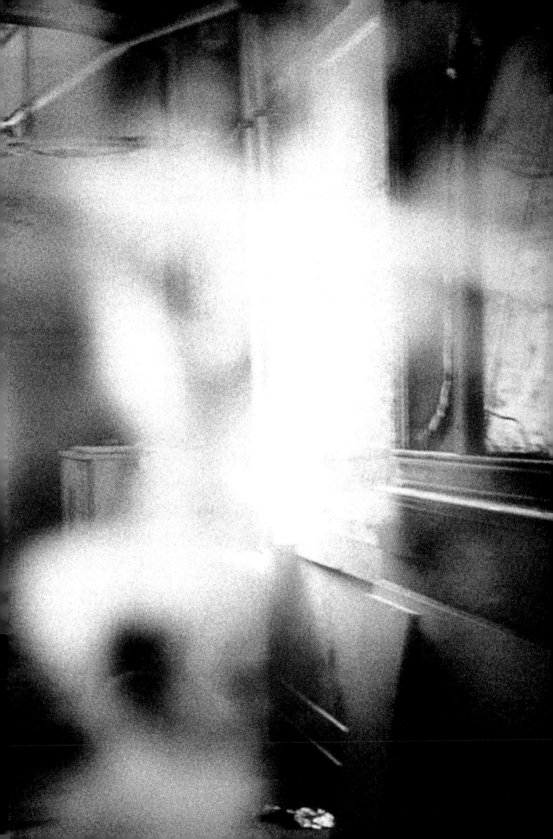

Berlin Nights

First Edition

Copyright © Hoxton Mini Press 2018. All rights reserved.

All photographs © Christian Reister

Introduction by Tom Seymour

Design and sequence by Friederike Huber and Christian Reister

Repro by Michael Booth/Touch Digital

Portrait on card insert by Kay von Aspern

A CIP catalogue record for this book is available from the British Library

ISBN 978-1-910566-41-1

First published in the United Kingdom in 2018 by Hoxton Mini Press

Printed and bound by: Livonia Print, Latvia

To order books, collector's editions and signed prints please go to:

www.hoxtonminipress.com

MIX
Paper from
responsible sources
FSC® C002795